MADAME GRÈS COUTURE PARIS

A French fashion historian, Olivier Saillard was the curator of the Fashion program at the Musée des Arts Décoratifs in Paris (2000–2010) and the director of the Palais Galliera (2010–2017). Since 2017, he has been the director of the Azzedine Alaïa Foundation and, since 2018, the Artistic Director of Maison J.M. Weston.

Anne Graire is the granddaughter of Madame Grès, for whom she also served as personal secretary. She is a freelance writer who specializes in fashion and culture.

MADAME GRÈS COUTURE PARIS

EDITED BY
OLIVIER SAILLARD

WITH CONTRIBUTION BY
ANNE GRAIRE

RIZZOLI
NEW YORK

New York · Paris · London · Milan

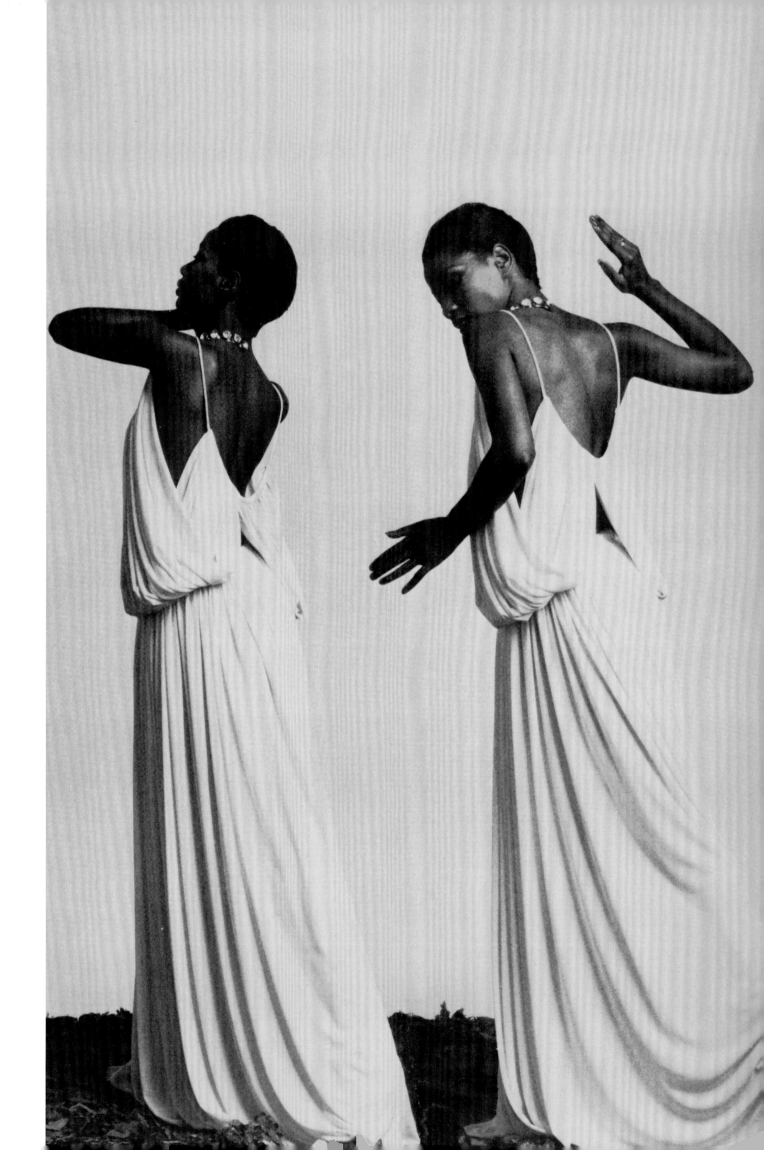

Draped dress in white viscose jersey from Racine

FRANK HORVAT
VOGUE FRANCE
MARCH 1978

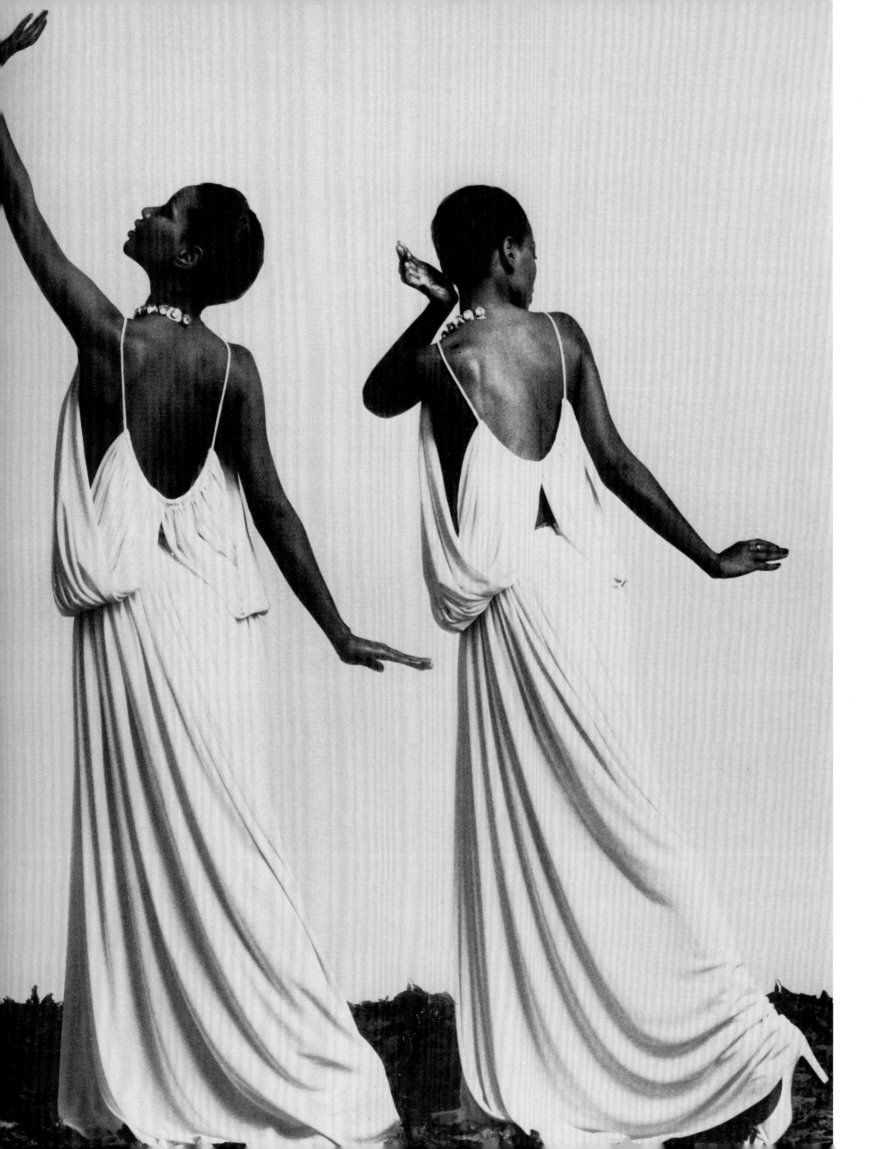

THE ART OF DRAPING

BY OLIVIER SAILLARD

1. EDMONDE CHARLES-ROUX, "UN DICTATEUR DÉGUISÉ EN SOURIS," *Paris Match*, JANUARY 1994, P. 57.

Madame Grès departed in the same way that she lived: silent and alone. What was she doing in that cell where she shut herself away? I picture her secretly making a ladder of silk...to escape like a fairy. She is gone, along with her secrets."[1] Where holding up mirrors to fashion and the profession is concerned, Edmonde Charles-Roux is a leading authority. Though not always flattering, concave or convex, her mirrors paint portraits that are accurate, and sometimes seductive or incriminating, of the designers and couturiers that she regularly rubbed shoulders with when she was Editor in Chief of *Vogue* magazine. An acclaimed biographer, Edmonde Charles-Roux devoted hundreds of pages to Mademoiselle Chanel in her famous book, *L'Irrégulière*[2], but only two columns to Madame Grès! And yet her uncompromising taste for research and analysis remained unfailing: the few lines that she wrote about the woman she liked to call the "dictator disguised as a mouse" are just as sharply observed, even though within the confines of a right-hand page in a large-circulation magazine. Charles-Roux also referred to her "the world's most secretive, most silent, and most determined woman," alluding to Madame Grès's "abbess-like silences,"[3] but admitted to having nothing to say beyond her work.

2. EDMONDE CHARLES-ROUX, *L'Irrégulière ou mon itinéraire Chanel*, PARIS: GRASSET, 2009.

3. EDMONDE CHARLES-ROUX, *Paris Match*, OP. CIT., P. 57.

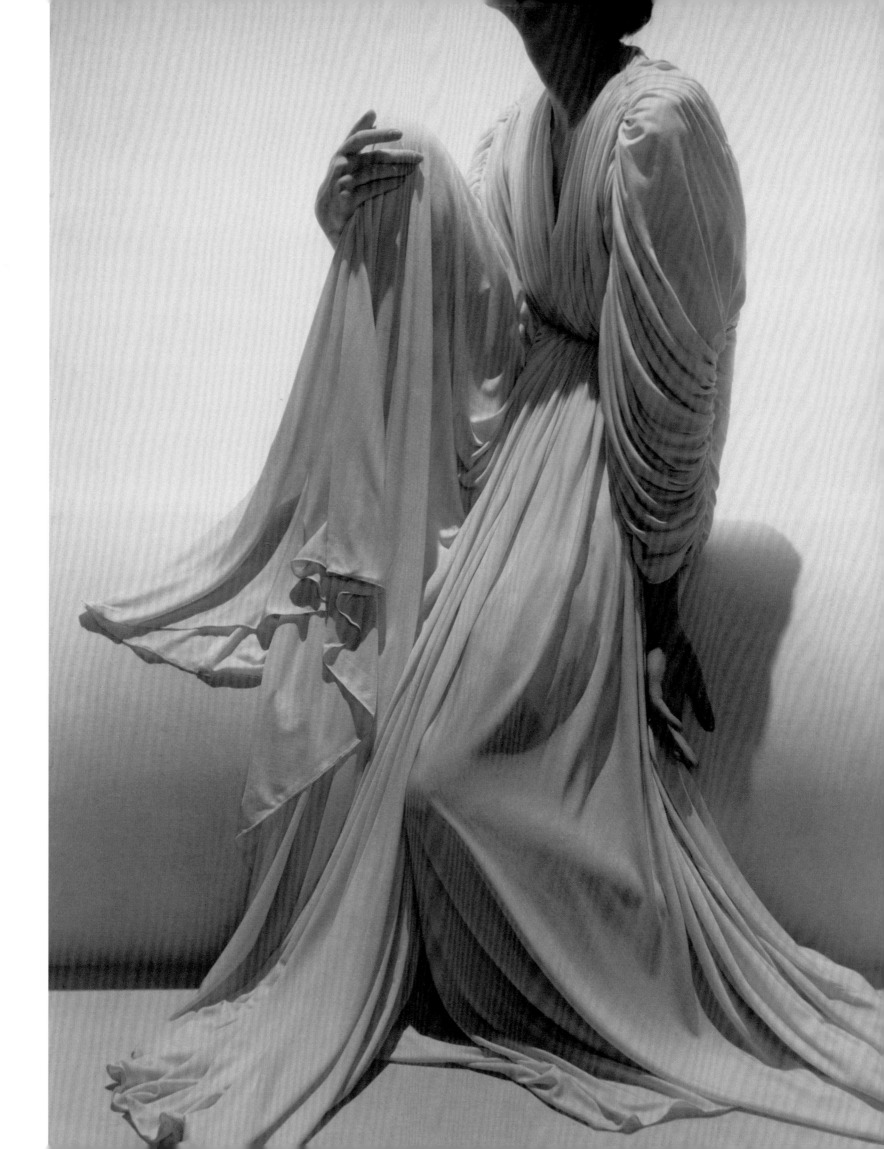

PORTRAIT WITHOUT A BIOGRAPHER

4. IBID.

5. LAURENCE BENAÏM, *Grès*, PARIS: ÉDITIONS ASSOULINE, "MÉMOIRE DE MODE" SERIES, 1999, P. 4.

6. MARYLÈNE DELPHIS, "MADAME GRÈS, HELLÈNE DE PARIS", *Le Jardin des Modes*, DECEMBER 1980-JANUARY 1981, PP. 14-15.

7. SAHOKO HATA, *L'Art de Madame Grès*, TOKYO, BUNKA PUBLISHING BUREAU, 1980, P. 254.

For reasons that remain mysterious, Madame Grès purchased the entire stock of a book about her that was published in Japan, essentially preventing its distribution. And in the early 1980s, with no explanation, she pulled out of a retrospective exhibition in Paris, even though it had been announced in the press. "She knew I was writing an article, and she did her utmost to avoid answering any of my questions," recounts Charles-Roux. Nonetheless, Madame Grès did ask the journalist, "What are you going to write about me?"[4]—while not hiding her disdain for the exercise. When another journalist or columnist came to "spy on" her, Madame Grès responded, disenchantedly: "I have nothing to say and everything to show. All I do is work, work, work. When I'm not sleeping, I'm cutting fabrics. That's what my life is."[5] In 1980, when Marylène Delphis interviewed Madame Grès in advance of the cancelled 1980s exhibition, she began with, "You met Paul Valéry..." and Madame Grès responded, "He used to come here," casually gesturing to her large ivory salons, then swiftly added that she "never spoke to him." Delphis continued, "You knew Giraudoux, Cocteau, Édith Piaf...," but gave up on the conversation, because all Madame Grès wanted to say was the famous "I work."[6]

Madame Grès is not so much a subject as a theme—the theme of life's work. She is less a monograph than a catalogue raisonné in which private life, or the absence of a private life, in her view, has little place. Associated with the iconic image of the couturiere with pins in her lapel—as generations of male fashion illustrators have imagined her—Madame Grès was without equal in terms of discouraging biographers, attracting them and then immediately disappointing them. Because behind the flashy yet obscure gimmicks—Madame Grès drove a blue Jaguar, the seats of which she had upholstered in mink—"each day would be identical to the one before."[7] It was as if, having set in place all the glitzy attributes of a life of luxury, Madame Grès had decided not to adopt such a life, preferring instead one of relentless work. She had her car equipped with a television, but never watched it, for example. The one leisurely pursuit she allowed herself were visits to the flea market, which she walked around in silence in a faded raincoat, accompanied only by Musig, her horrible Pekingese. Like her friend Balenciaga, another high priest of modernity, Madame Grès did not appreciate the dissipated tastes of her era. Austere in character, she loved furniture from the Haute Époque (roughly middle ages to 17th century), as well as 17th-century Dutch paintings and Byzantine crosses. It was in the workshop where she came into her own. She had two of them at her couture house—one for fine dressmaking, the other for tailoring—one at the boutique, and yet another at her home. Work always trumped romance.

Evening dress
GEORGE HOYNINGEN-HUENE, *HARPER'S BAZAAR*, SEPTEMBER 1936

"I don't have a private life as such. I dedicate myself entirely to my couture house and the people working there. I think that, ultimately, the creative act remains for me the sole means of addressing those concerns [...]. Each day would be identical to the one before. And my family certainly must have suffered from that even more than I did. I tore myself away from them, from the sweetness of home, from the intimacy of family celebrations and holidays. And it wasn't only my own family that I neglected—to some extent I had also to sacrifice the private lives of the people who worked with me."[8]

Nothing could distract this most obstinate and hardworking of fashion designers. She named her signature perfume *Cabochard* ("Pigheaded") in a direct—and humorous—allusion to her stubbornness. From the 1930s through the 1980s, she found fulfilment only in the collections that she created. For six decades, she would cut and recut the fabrics that were the object of her obsession—living sculptures—steering clear of, and looking down on, fast-changing fashions. At the top of an advertisement from the freewheeling 1970s, she boldly declared that rather than lower her standards in her first venture away from haute couture, she would bring ready-to-wear up a level: *"Je ne suis pas descendue dans la rue, j'y suis montée."*[9] (The phrase is also a play on "taking to the streets.") Her fate dictated by a handful of pins, a pair of scissors "hanging from a ribbon around her neck, like a crucifix."[10] Such was Madame Grès. The dresses were her heroines. Grès would never forget to set her famous jersey turban firmly on her stubborn head, never allowing herself any horizons other than the material that was responsible for her success—that plowed the furrows of her life, but also of her isolation, in its tightly controlled pleats. "I've always thought that life is an endless struggle, and I was convinced that if I gave up on that struggle, life itself would give up on me."[11]

A workaholic, Madame Grès would labor until two in the morning and be back again at work at six a.m. When asked about her technique, she responded, disparagingly, that sewing was the one thing she never did! When she was given the Dé d'Or (Golden Thimble) in 1976—an award for the best collection of the season—Madame Grès waved the Cartier-made trophy in the air and remarked, in amusement, "I've never had any others. I hate sewing. I never sew!"[12] Over the course of various interviews that sought to penetrate the secret of her creative process and longevity, she responded: "I never create a dress on the basis of a sketch. I drape the fabric on a mannequin, then I examine its character in depth, and that's when I pick up my scissors. Cutting is the critical and most important stage in creating a dress. For every collection that I produce, I completely wear out three pairs of scissors."[13] While Madeleine Vionnet's style was embodied by crêpes and chiffons, soft fabrics whose architecture she revealed through reinventing how they were cut, Madame Grès instead distinguished herself through jersey—silk jersey in particular—and expressed its sculptural virtues more than anyone else. Because "the material demands it," she would prepare her clothes by draping the fabric on a model's or client's body, securing it in place simply by the use of pins. Legend has it that because of her obsessive fear of being copied, she would take the rough mock-ups home and hang them on wooden mannequins in her apartment so she could rework and hone them in isolation.

8. *IBID.*, P. 254.

9. *Vogue France*, AUGUST 1980, GRÈS BOUTIQUE ADVERTISEMENT, P. 27: "JE NE SUIS PAS DESCENDUE DANS LA RUE, J'Y SUIS MONTÉE."

10. LAURENCE BENAÏM, *Grès, OP. CIT.*, P. 15.

11. SAHOKO HATA, *L'Art de Madame Grès, OP. CIT.*, P. 253.

12. *Dépêche du Midi*, 31 JULY 1976.

13. SAHOKO HATA, *L'Art de Madame Grès, OP. CIT.*, P. 254.

HEADLONG

Madame Grès's ambition was to rediscover the body. She wanted the dress to work with the wearer's movement, harmonizing a relationship that sometimes favors a distancing and sometimes a coming together of clothing and attitude. She introduced a sense of naturalness through the cut, which she said she mastered precisely because she had no knowledge of strict dressmaking techniques. Seeing herself as a sculptor, she invented other tools for her profession. She was not one of those designers who instigated fashion revolutions, which are more optical than concrete. Rather, she quietly brought about a substantial "evolution" in the discipline and endowed it with a plumb line that was embodied by her draped gowns in all their purity. Marylène Delphis rightly emphasizes this. In line with the custom that continues today, Christian Dior named his collections from the spectator's viewpoint—*Zig-Zag, Ovale, Tulipe, H, A*. However, Madame Grès's were characterized solely from the point of view of the relationship between the designer and the body being modeled, or between the item of clothing and the body wearing it. Her lines then were called *jaillissantes* (spurting or gushing), *lianes* (creepers), *enveloppantes* (enveloping), or *à corps perdu* (headlong). The fabric, which Madame Grès treated like a sculptor treats stone, is the link between the body, always the point of reference, and the clothing.

Curious to embrace the full range of possibilities open to her, the self-professed "home worker" (*ouvrière en chambre*) recalled the time when she re-purposed a Lurex weave used for swimsuits (Hélanca nylon) into a sumptuous evening gown. Some fabrics were manufactured exclusively for her, like the silk-and-metal lamé made in 1938 by Bianchini Férier, of which no more than seven centimeters could be produced per day. All jersey fabric names are of course associated with her. Djersafyn, Djersyl, and Djersatimmix, among others, in broad widths, evoke the sumptuous, monochrome draped gowns that dominated her output. They were made of high-quality silk or polyamide. Toward the end of her life, when her financial resources were more limited, Madame Grès would use jersey fabrics that were not always of exceptional quality but which she managed to master because her expertise in the art of draping. However, to limit Madame Grès's entire oeuvre to the sole exercise of draping would be an error. In the 1950s, she was unparalleled in her ability to tame taffetas and woolens. Her short cocktail dresses with wide pinch pleats and asymmetrical, streamlined forms are outstandingly light. Those of her contemporaries—whom Madame Grès reproached for their reliance on drawings, illustrations, and superficial, showy ideas that were, in her view, the source of haute couture's decline—are by contrast starchy and heavy inside.

A rare example of a fashion designer who was able to switch between soft dressmaking and tailoring, she created exceptionally fine jacket and skirt ensembles in flannel or men's suit fabrics. She surprised by using a blanket fabric to produce ravishing three-quarter-length coats with kimono sleeves. In the 1950s, this range, which was by no means an insignificant one among her collections, placed her alongside the American designer Claire McCardell. Both represented an enlightened form of what ready-to-wear would become. They were its stylistic pioneers, designers who favored simple shapes, with solutions and methods of cutting set up as aesthetic principles. Paradoxically, for a long time Madame Grès refused to involve herself in the democratic enterprise of ready-to-wear, as she did not want to

lose sight of the supreme cult of the client. In the 1960s and 1970s, short dresses and equally short coats were surprising not only for their minimalism but for the quality of their execution. They seem to be genuinely molded, intolerate to ornamentation, and drew their imaginative quality from their sculptural dimension. Made of double-faced fabric particularly favored by Madame Grès at the time, these garments had few equivalents in French fashion. She combined the methodology and technical refinement of haute couture with her striving for modernity, taking the couturier's métier beyond its etymological domain of sewing, or couture, and positioning it truly in the realm of the "designer."

<div align="center">III</div>

GRÈS TO THE LETTER

Madame Grès, whose real name was Germaine Krebs, began her working life in the 1930s. In 1933, at Rue de Miromesnil in Paris, she joined forces with Julie Barton to launch the Alix Barton couture house, which became Maison Alix in 1934, at Rue du Faubourg-Saint-Honoré. A great success, the firm achieved particular renown for pieces that evoked "statues from antiquity but which, as paradoxical as it may seem, are absolutely suited to the modern life of our western metropolises."[14] Following disputes with her associates, in 1942 Krebs founded the House of Grès, the name being a partial anagram of Serge, her husband's first name. As someone who aspired to become a sculptor, the name of Grès is an apt one: by definition the word is a sedimentary rock formed of grains of sand (one translation of *grès* is sandstone). And indeed, all manner of sand tones were frequently found in her color palette. Grès-Serge did not withstand the branding. The marriage fell apart when her husband left permanently for Polynesia. However, Madame Grès remained, a determined couturier with rock-solid resolve, certain of her vocation and of her solitude, which she proclaimed in the form of a plaque at the entrance to the building at 1 Rue de la Paix!

In the transition from Alix to Grès, there were no notable changes. Economical in her art yet a big spender in life, Germaine erased four letters and replaced them with four others, while modifying nothing of the style that had brought her fame since her first perfectly pliable draped pieces in Albène jersey. Whether working as Madame Grès or Madame Alix, she remained an apostle of the same stripped-back approach (the word "minimalism" did not yet exist), and in the ambience of a cathedral, one collection followed meditatively after another. Tones of neutral white predominated the salons, which were decorated with the economy of luxury that favors space over clutter. The boutique was described in *L'Officiel* as being "white like an Athenian temple."[15] It was said that Madame Grès would habitually double-lock the doors as soon as a show had begun, like at a theater, so that the audience could focus on the ceremony of the dresses. Instead of showing against the din of a soundtrack, she preferred the orchestrated silence of presentations where all that mattered was her work. Some of her black draped garments were reminiscent of a priest's cassock. From gathering effects defined as "pointed-arched" or "ogival" (ogives) to overcoats from 1957 described as "round-arched" or "round-headed" (*en plein cintre*), a 1949 collection displayed a forthright monastic style. In 1962, the "hollow belly" (*ventre creux*) frock coats evoked the simplicity that led Madame Grès to reject ornament and distraction. And yet, her cut-out backs and emphasized

14. *L'Officiel de la couture et de la mode*, DECEMBER 1935, P. 113.

15. *L'Officiel* [...], MARCH 1951, P. 171.

hips underline a confident sensuality that is far from ascetic! In the gowns of the 1930s photographed by George Hoyningen-Huene or those of the 1970s photographed by Helmut Newton or Guy Bourdin, the neoclassicism of the pieces—some of which required up to three hundred hours of work to make—is always alluded to. This stylistic consistency, often considered a sin in the fickle world of fashion. As Marylène Delphis noted, Madame Grès represented the "tranquility of French tradition and the turmoil of the avant-garde."[16] of which she was a forerunner.

16. MARYLÈNE DELPHIS, *Le Jardin des Modes,* OP. CIT., PP. 15-16.

Two elements of her output can be singled out. The first is clearly identified by the use of drapery, notably for evening gowns but also for beachwear. Beginning at Maison Alix and into the 1980s, Madame Grès enjoyed including elegant beachwear for each collection, using rustic or refined textiles. Drapery for evening gowns with hints of antiquity continued through the decades, often eclipsing the other designs. *L'Officiel* said they "are as much sculpture as they are fashion."[17] One columnist, describing a collection from 1938, wrote: "Here we cannot talk of cut, but rather of sculpture: Alix seems to carve and chisel away at the material, to knead and mold the fabrics until they have taken on the very shape of her dream."[18] In 1970, as younger generations of fashion designers and makers were rediscovering Grès, a journalist wrote that her creations were "carefully considered and meditated upon, to the point of making us forget that they are born also from the slashing of scissors."[19]

17. *L'Officiel* [...], MARCH 1937, P. 52.

18. *L'Officiel* [...], JUNE 1938, P. 66.

19. *L'Officiel* [...], SEPTEMBER 1970, P. 67.

The second element, often overshadowed by her iconic drapery, is in the Persian, Indian, and Berber influences that are seen throughout her different periods. Costumes from the Far East, the Middle East, North Africa, or Central Europe were incorporated into her designs, but without the usual exaggerated folkiness or exoticism. The decorative or constitutive simplification inherent in traditional clothing is dotted throughout her collections. She interpreted Turkish pants, Egyptian forms, Bedouin and Berber styles (1949), and an Indian spirit in a Himalayan coat (1959) without straying into picture-postcard mode. Ideas that she brought to maturity—long dresses of Hindu princesses (1935), kimono sleeves (1947), and multiple capes—all allude to travels perhaps never undertaken. It was structure, rather than ornament, that Madame Grès sought. The technique of "seamless" clothing, which was already there at the beginning and which she made extensive use during the last decade of her career, is in keeping with traditional garments that are cut flat in a single piece.

The character of Grès's collections, confirmed in the 1930s and still onward into the 1970s, continues to astonish with its timelessness. While some of the pieces indicate an inspiration, there is no dominant theme. Making no concessions and offering no commentary, Madame Grès delivered her designs independently of any passing trends. In 1966, a press release commented on the collection's structural spirit—the morning dresses and day dresses, the evening dresses and the ones "to wear at home"[20]... Madame Grès very much belonged in the world of couture. She knew how to compose an entire wardrobe and "retained, like a professional memory, that long-lost inflection of clothing through the different hours of the day."[21] This reading of a collection, where each piece is made to stand alone, seems to guarantee a form of classicism that defies dating. Even the colors never betray the age of any piece. Particularly skilled with muted and faded tones, Madame Grès was an inventive colorist who had her own lexicon. Reddish-brown, chestnut, cinnamon, hyacinth, taupe, tortoiseshell, bronze, verdigris, black-currant red, all the beiges, off-whites, and deep blacks together compose a chromatic harmony that is still seductive and delicious today.

20. HOUSE OF GRÈS PRESS RELEASE, SPRING-SUMMER 1966.

21. MARIE-JOËLLE GROS, "MADAME GRÈS, LA MORT AU SECRET," *Libération,* 14 DECEMBER 1994.

When asked what was most crucial in fashion, Madame Grès replied: "As soon as you find something that is personal and unique, you need to take full advantage of it and keep working at it unremittingly, taking it as far as you possibly can. Equally, you need to perfect your own technique and never neglect or overlook any detail." She added: "For a dress to survive from one era to another, it must be extremely pure."[22] Antique but never historicist, traditional but not exotic, Madame Grès's output is a yardstick for modernity. She liked only Balenciaga and Yves Saint Laurent. Her relentlessness and obsessiveness gave her a strong drive to create. To the very end, when her business suffered unresolvable financial turmoil, Madame Grès continued to design and make dresses—sometimes even from makeshift and poor-quality fabrics, and yet every one was a triumph.

"At a meeting on June 22, 1972, the Comité Syndical de la Couture unanimously voted for Madame Grès to take up the post of president of the trade union. A way of paying homage to an outstanding individual, fashion designers wanted to underline how couture creation in its purest form remains the profession's primary concern, despite how methods of production may evolve."[23] In voting for the woman also dubbed "the Designer's Designer," the committee recognized a position and status of authorship that Madame Grès intransigently embraced. From making every one of her dresses herself, double-locking the doors for the duration of her shows, personally greeting and thanking those invited to be first to view her collections, Madame Grès took care of everything. On the rue de la Paix, as photographers and journalists tiptoed away, she would remain there, alone in her certainty and the gravity that "solitude is necessary and overwhelming."[24]

22. SAHOKO HATA, *L'Art de Madame Grès*, OP. CIT., P. 255.

23. COMITÉ SYNDICAL DE LA COUTURE PRESS RELEASE, 1972.

24. SAHOKO HATA, *L'Art de Madame Grès*, OP. CIT., P. 256.

Evening dress
ANONYMOUS, *HARPER'S BAZAAR*, 1939

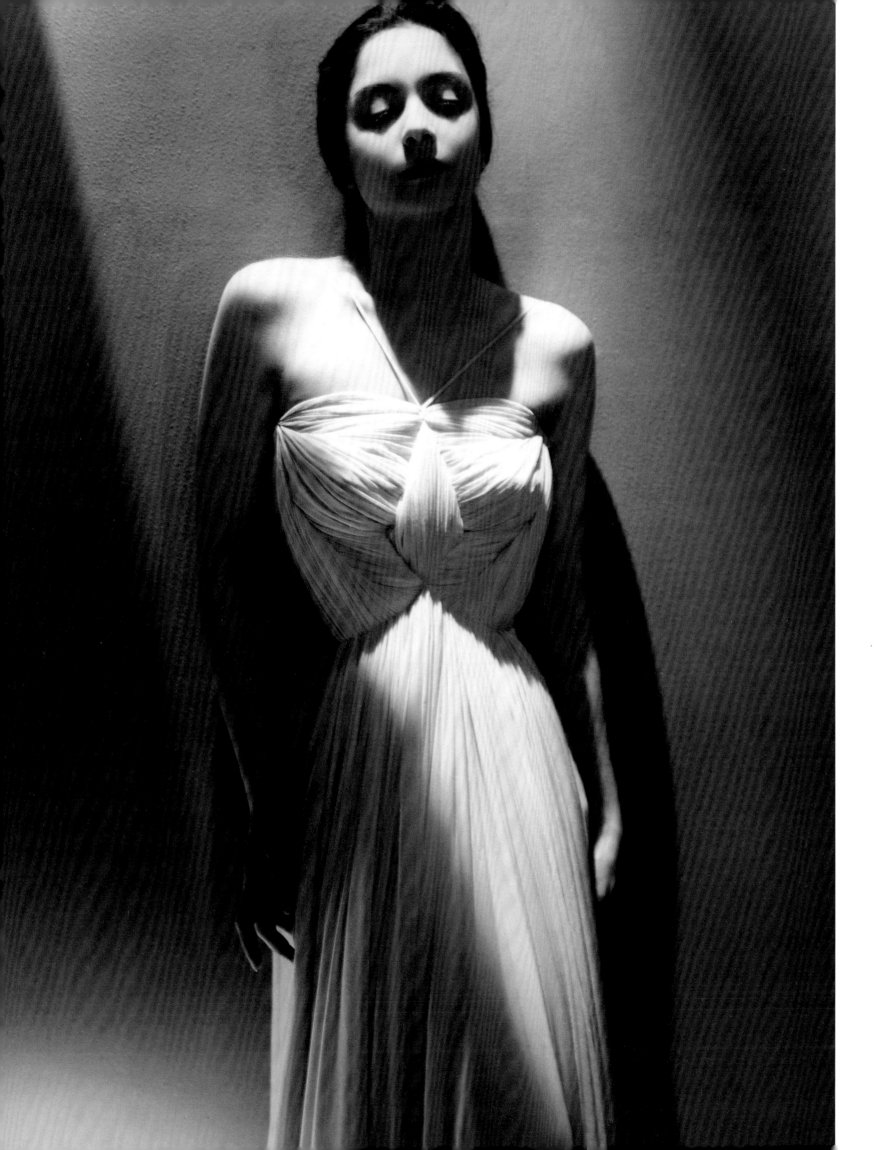

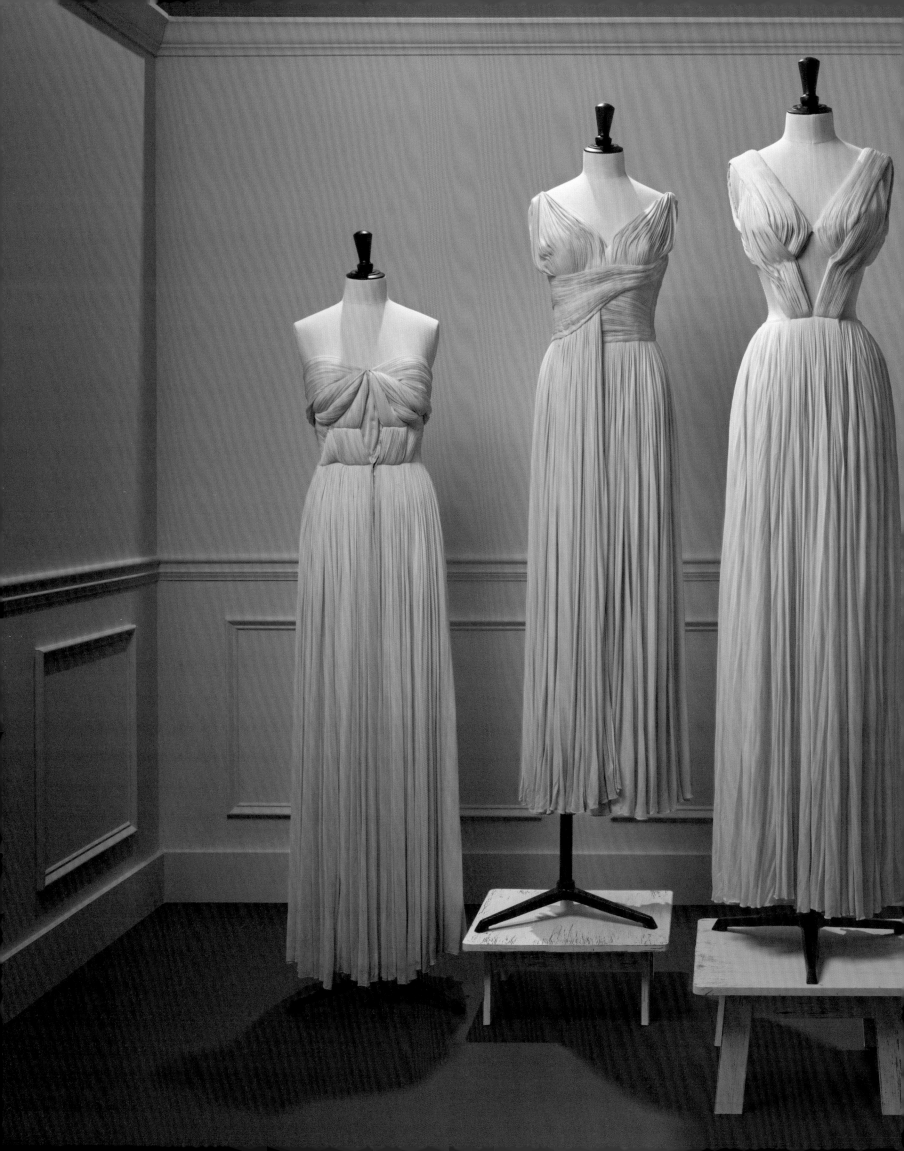

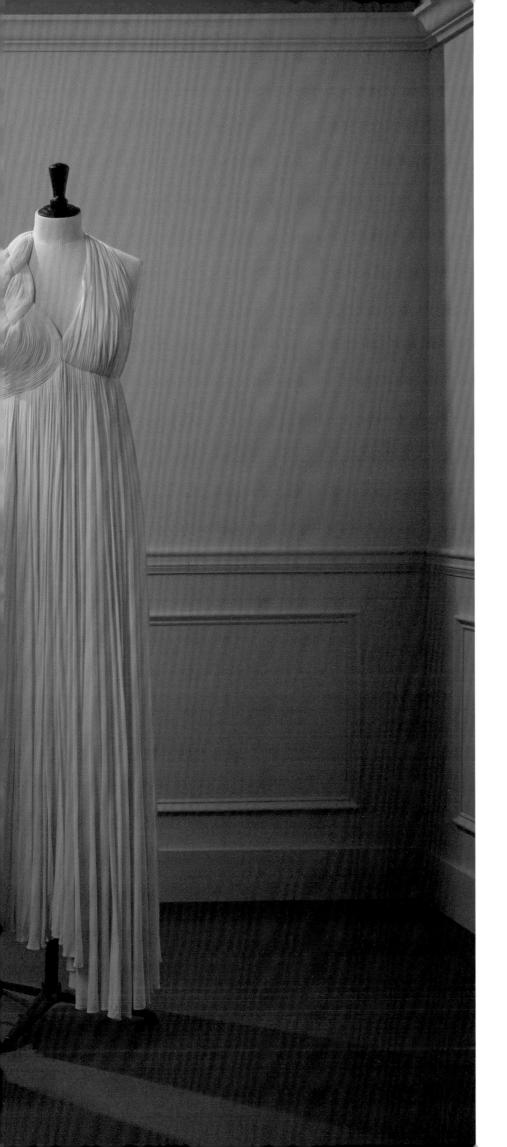

Strapless dress in off-white silk jersey
CIRCA 1947

Evening dress in ivory silk jersey
CIRCA 1956

Evening dress in white silk jersey
FALL-WINTER 1976-1977

Evening dress in white silk jersey
SPRING-SUMMER 1975

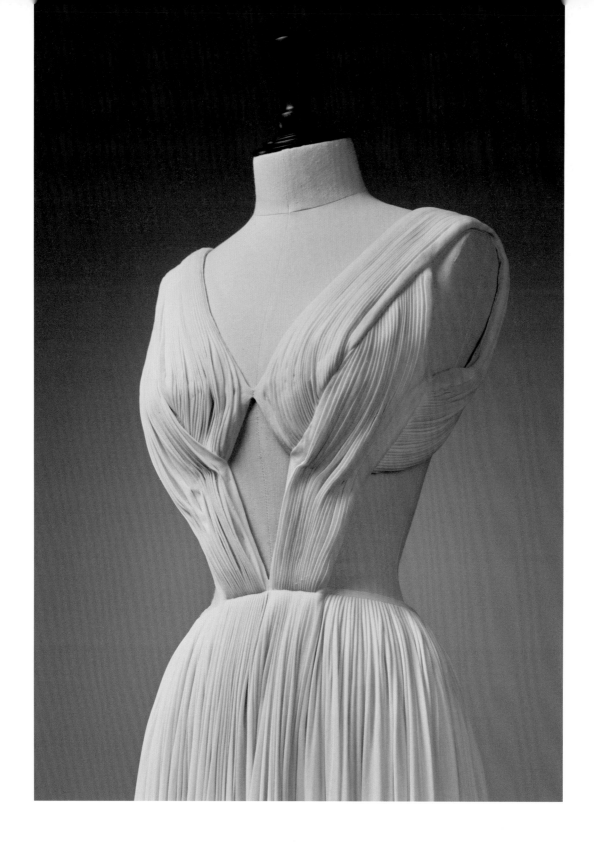

ABOVE
Evening dress in white silk jersey
FALL-WINTER 1976-1977

OPPOSITE
Long draped evening dress in taupe grey
pleated silk jersey with deep V-neckline
CIRCA 1945

18

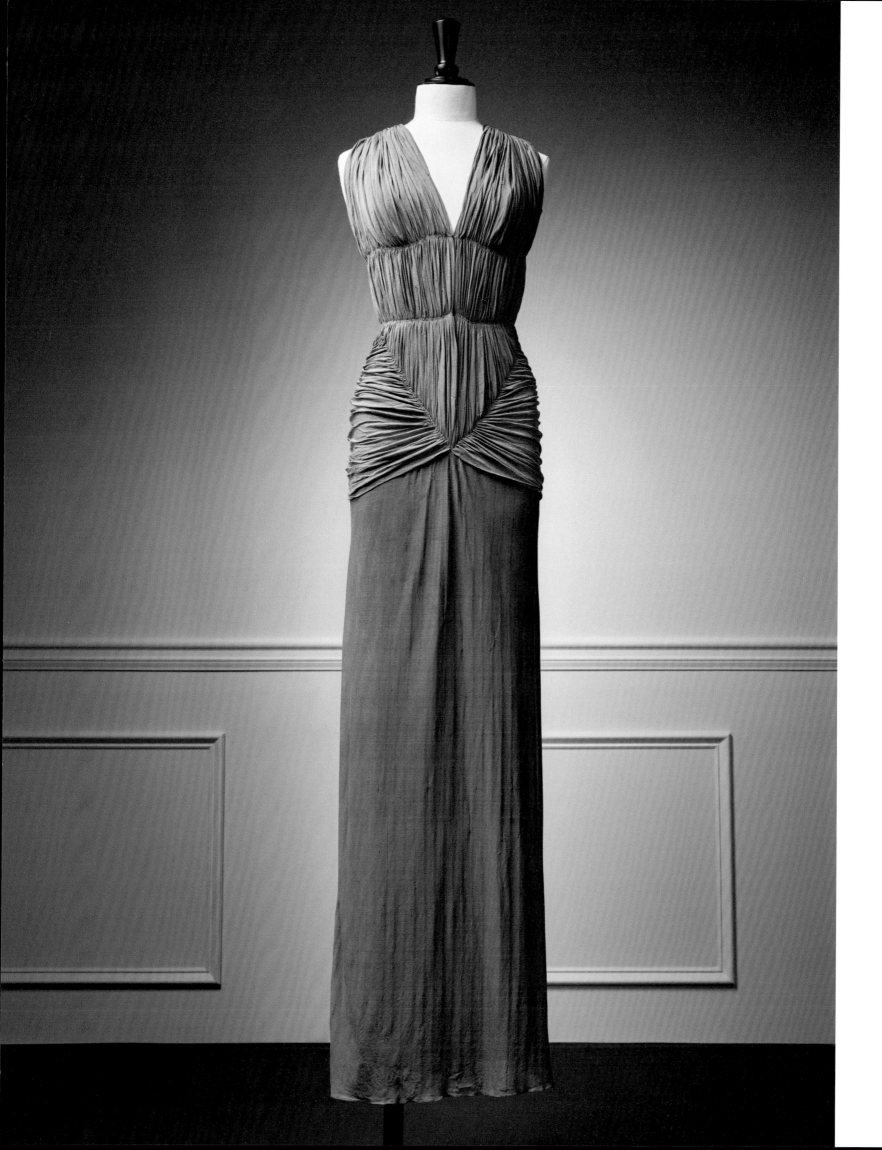

*Cocktail dress in pearl grey silk crepe,
boat neckline*
SPRING-SUMMER 1956

*Dress in champagne silk jersey and a deep
sweetheart neckline*
ATTRIBUTED TO MADAME GRÈS, CIRCA 1950

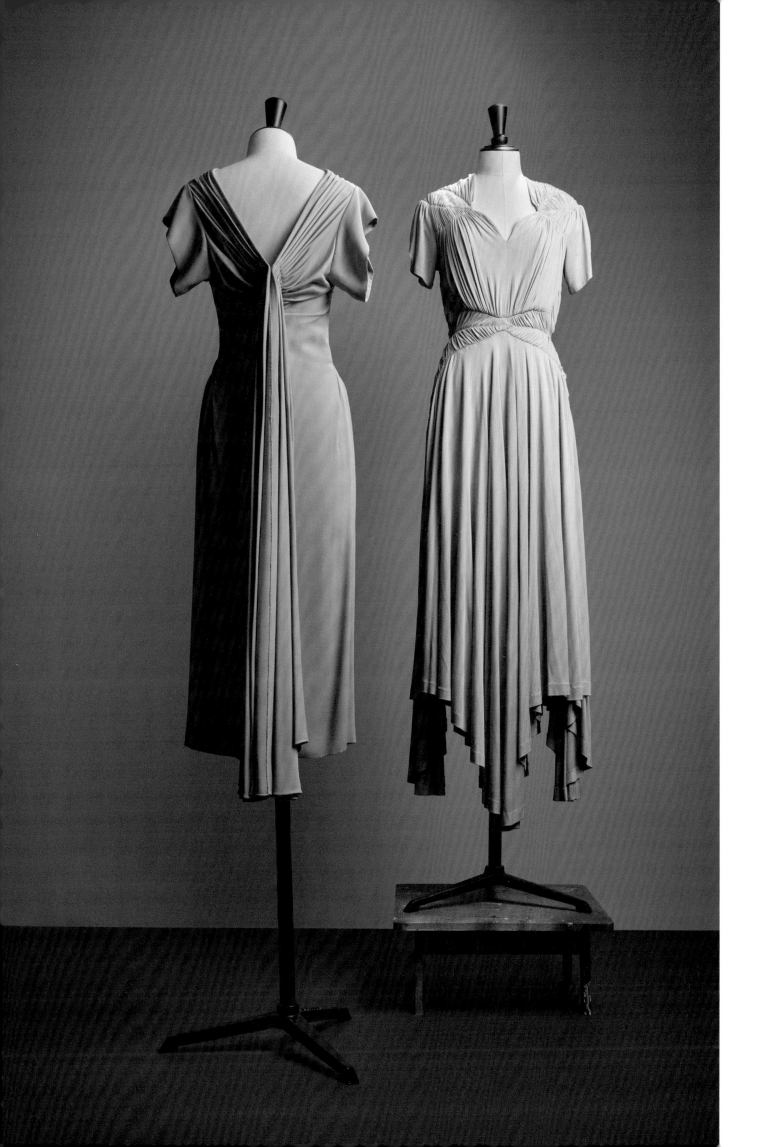

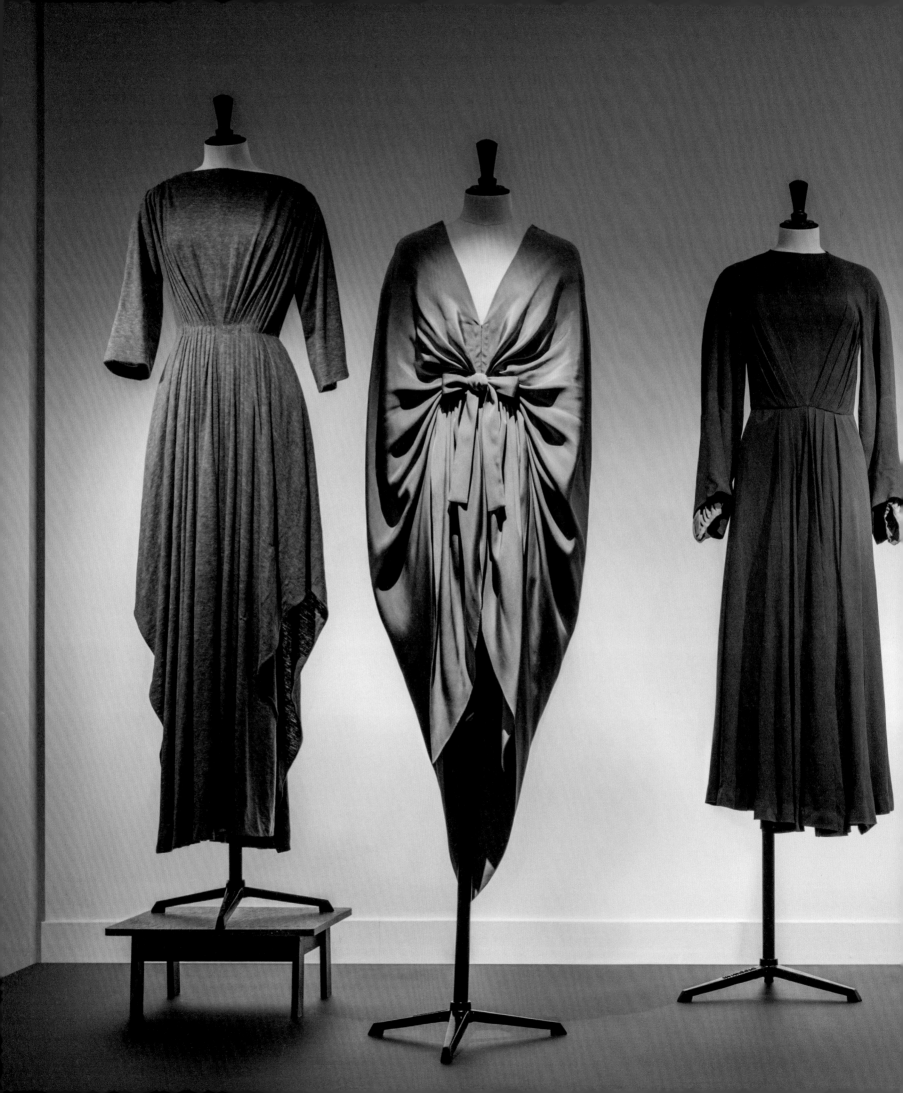

*Dress in olive-green wool jersey
with V-neckline*
FALL-WINTER 1969-1970

Cape in mustard silk with deep-V neckline
FALL-WINTER 1976-1977

Long day dress in terracotta silk crepe
CIRCA 1946-1947

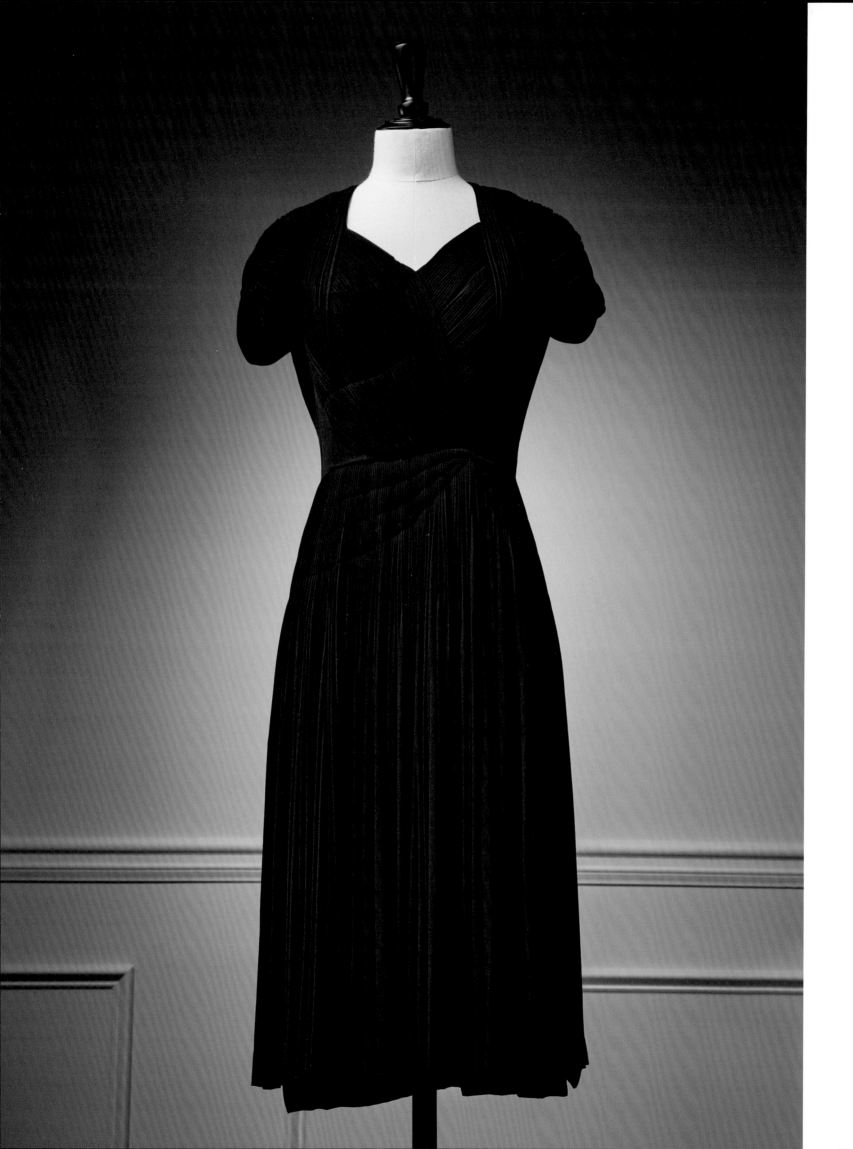

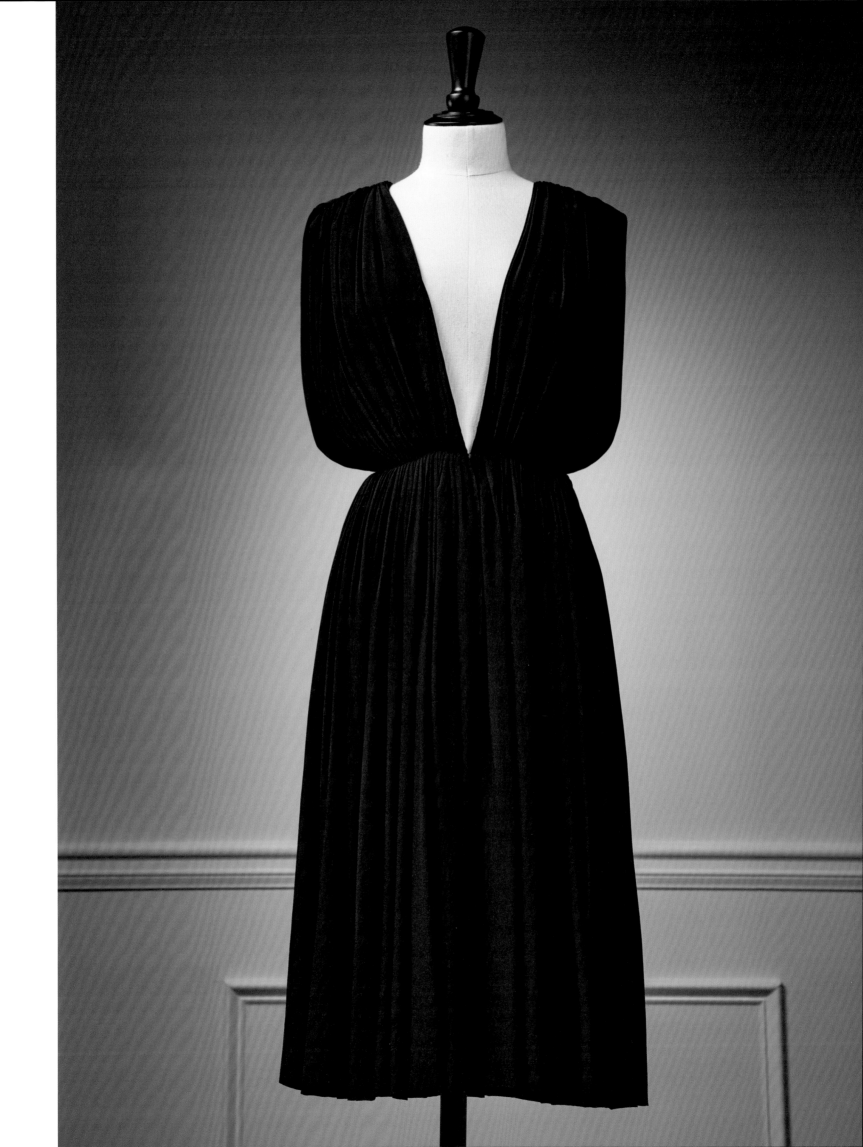

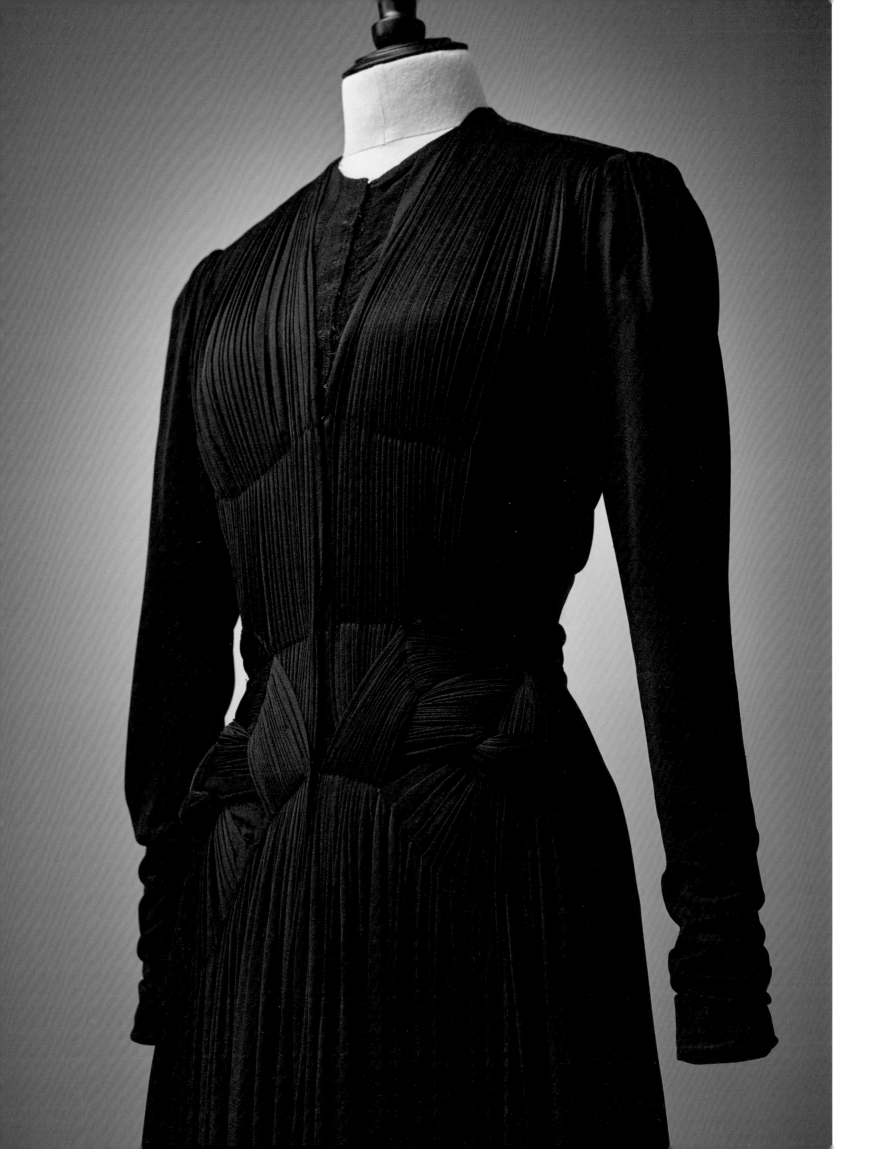

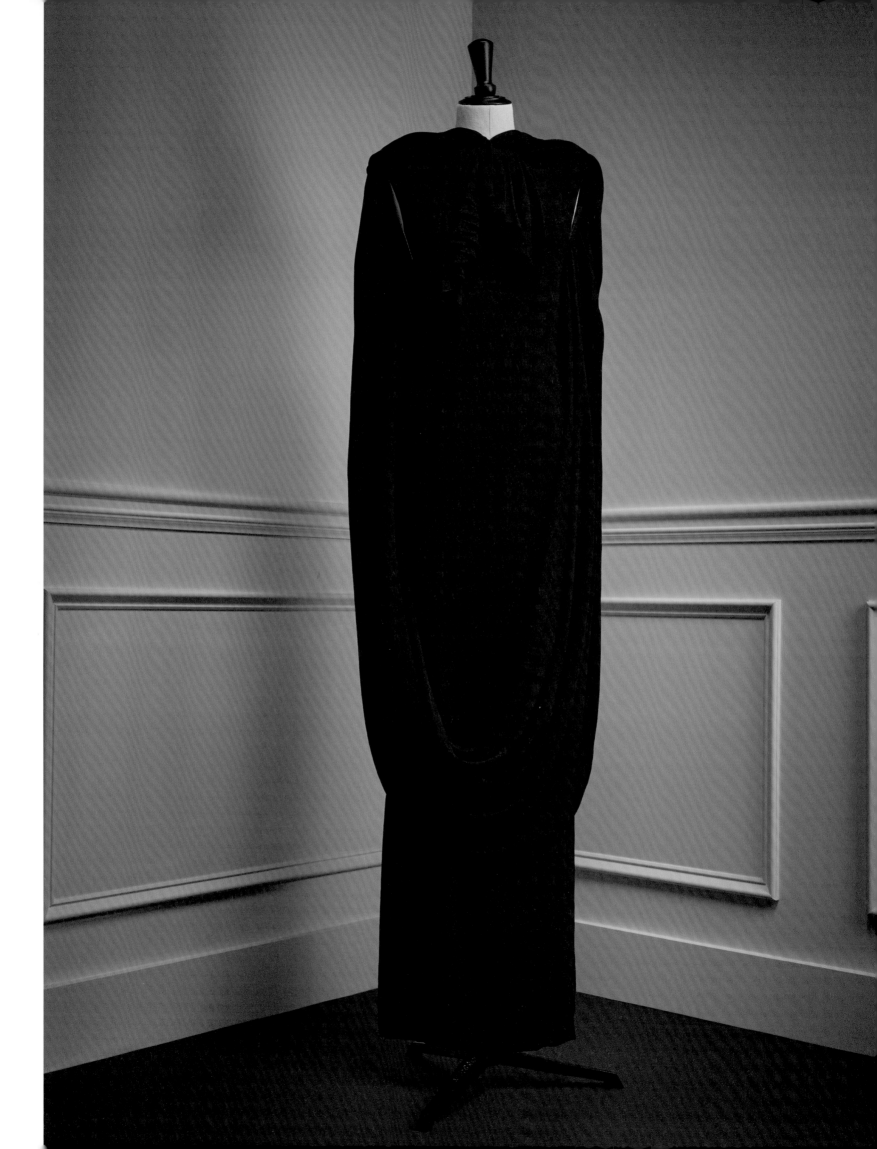

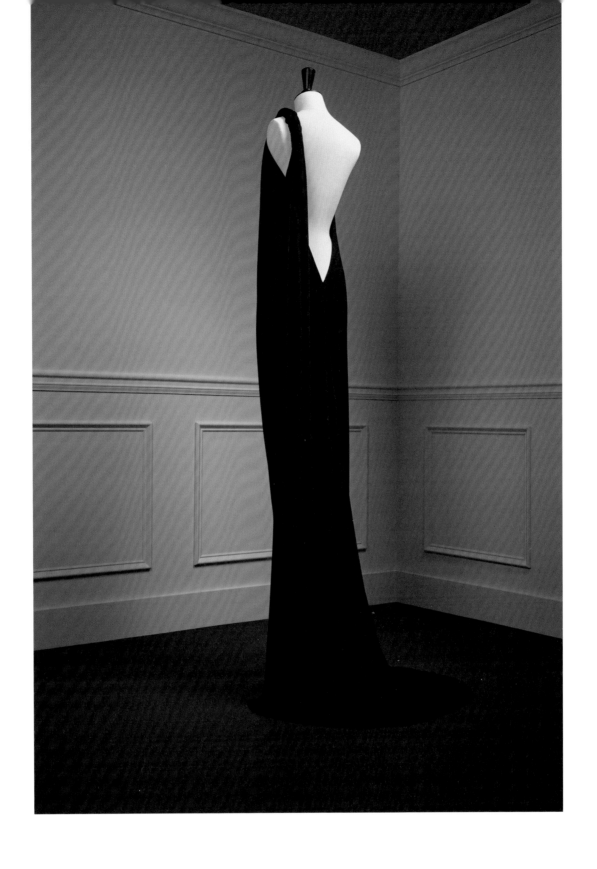

OPPOSITE
Evening dress in black silk crepe
CIRCA 1979

ABOVE
Evening dress in black silk jersey,
asymmetrical neckline
CIRCA 1963

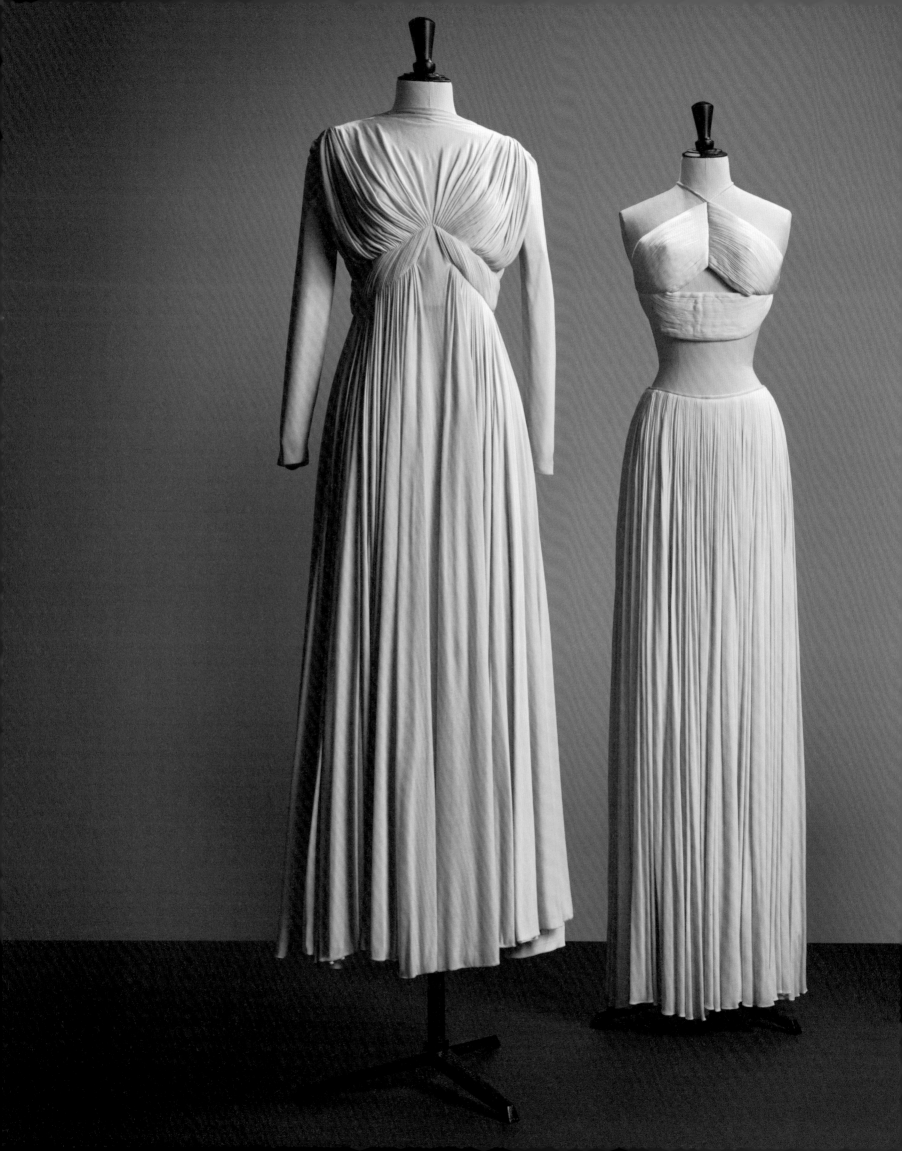

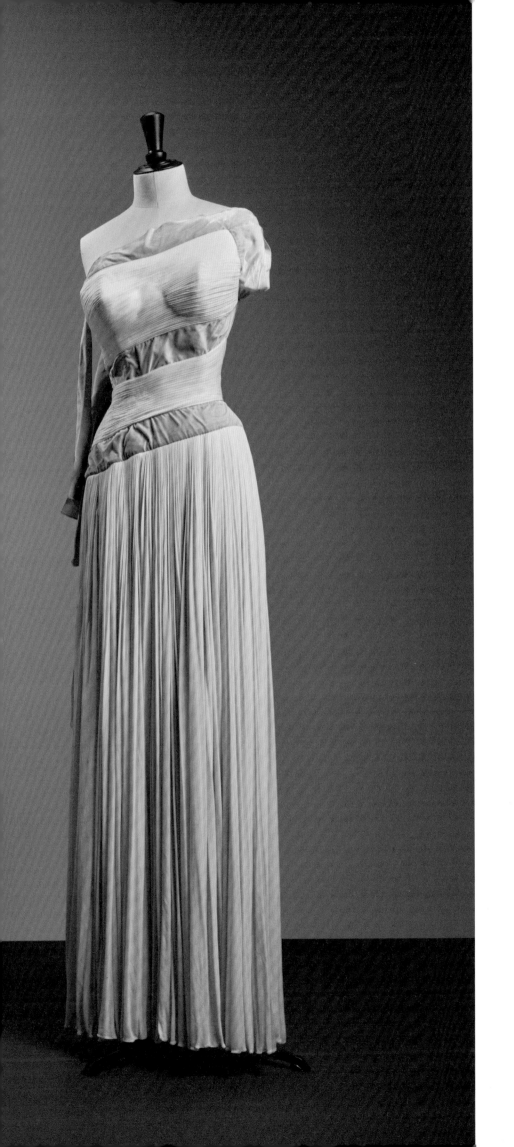

Evening dress in lemon-yellow silk jersey
CIRCA 1973

*Summer evening ensemble in lemon-yellow
silk jersey*
1973

*Asymmetrical evening dress in pale-yellow
silk jersey with tied velvet bands*
SPRING-SUMMER 1957

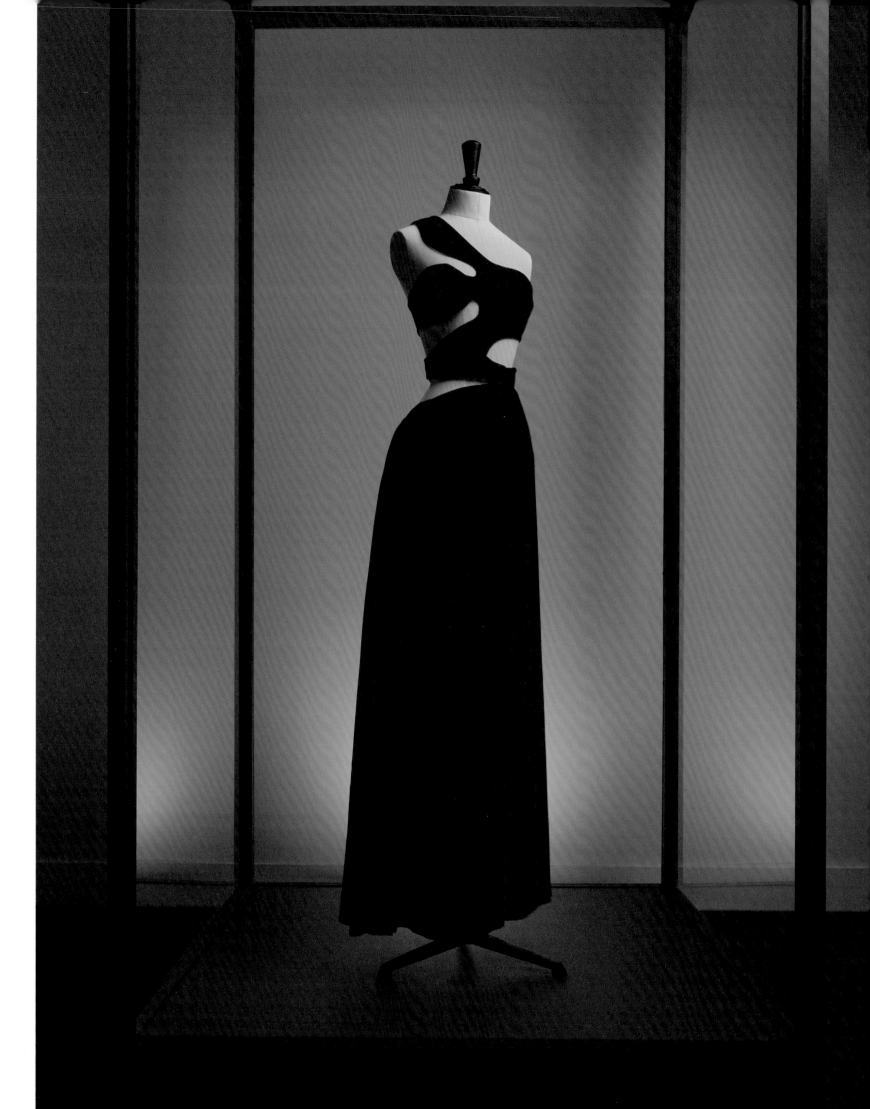

*Evening dress in black silk velvet
with an abstract cutout top*
FALL-WINTER 1980-1981

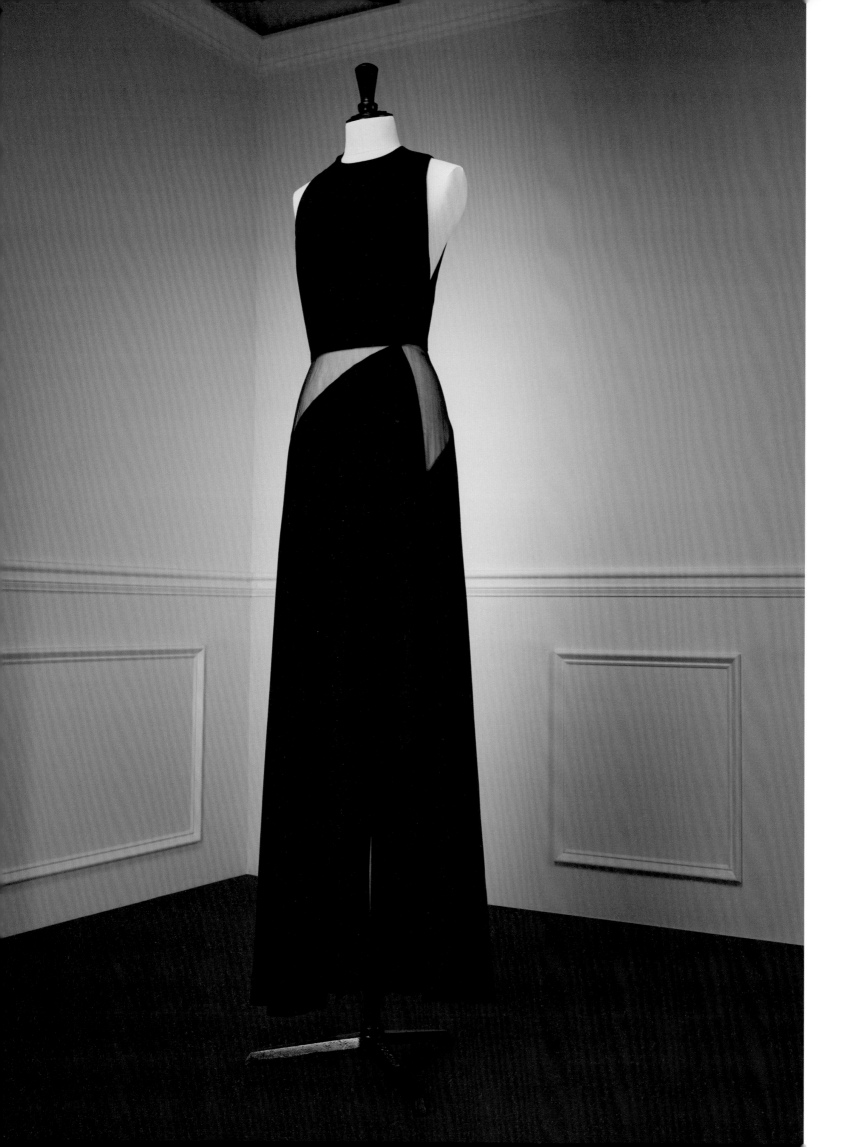

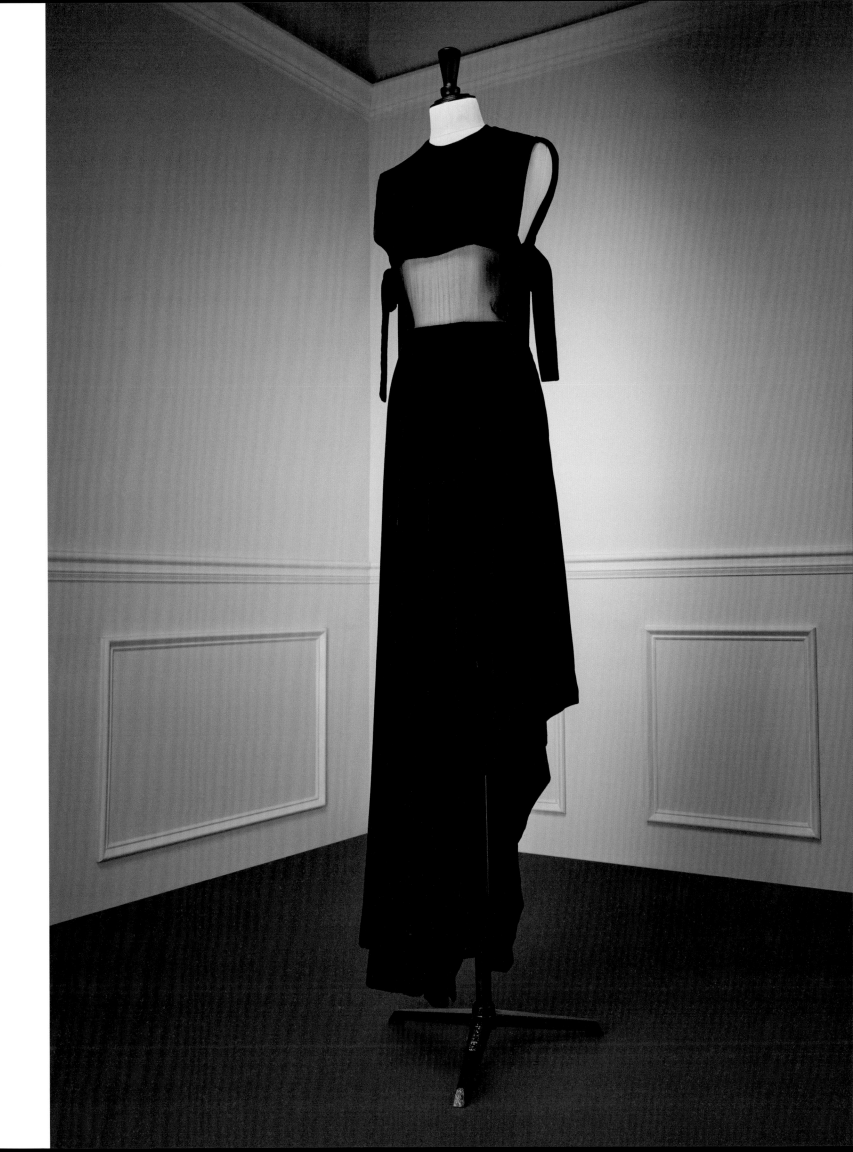

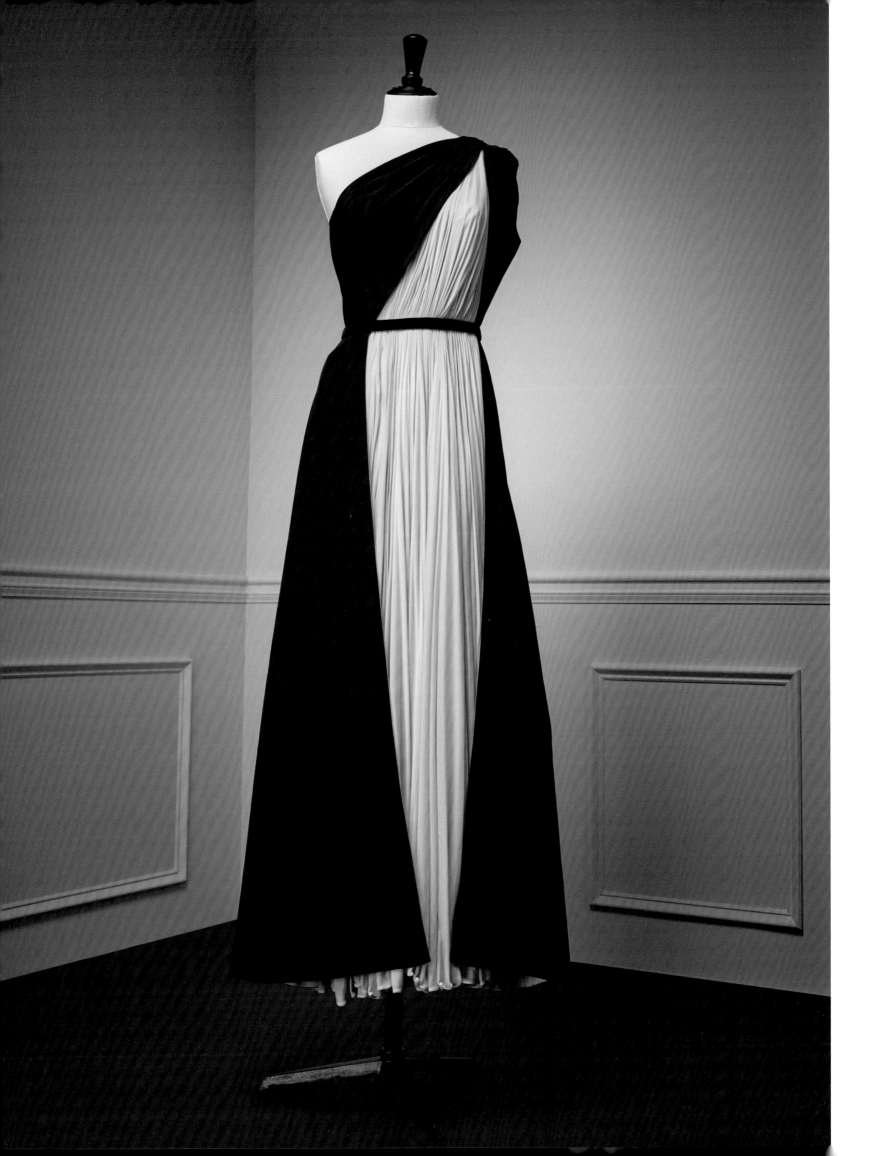

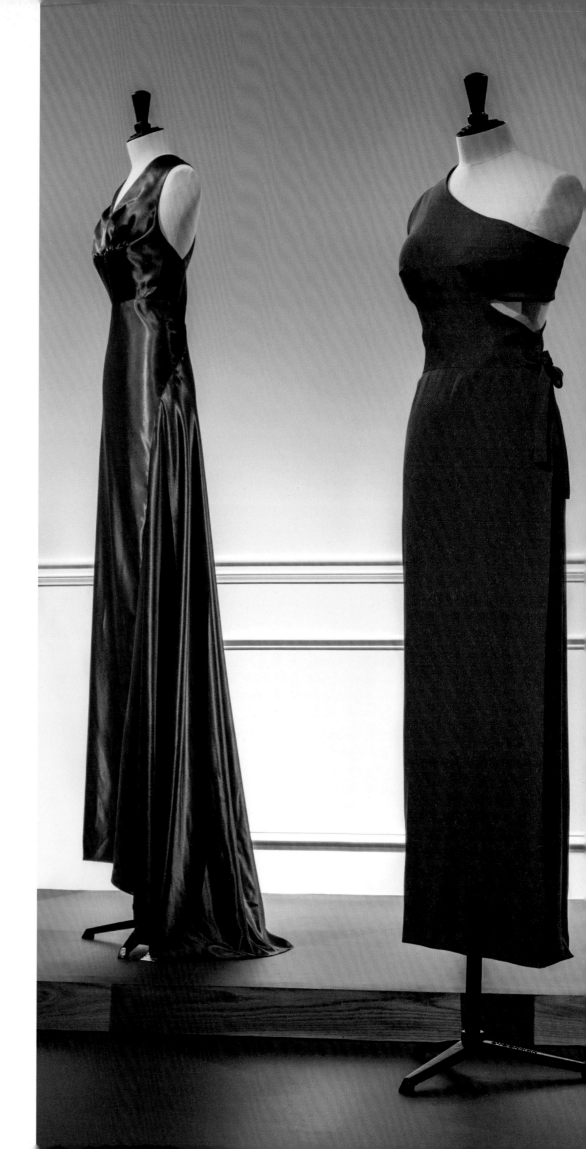

FROM LEFT TO RIGHT

Evening dress in light-violet silk satin cut on the bias
FALL-WINTER 1934-1935

Evening dress in raspberry silk crepe, asymmetrical cut with an integrated bra
FALL-WINTER 1971-1972

Asymmetrical evening dress in coral silk jersey cut and draped on the bias
SPRING-SUMMER 1973

Long tunic and long skirt made of coral silk jersey
SPRING-SUMMER 1976

Ensemble composed of a long tunic and skirt made of thin pleated jersey paneled with alternating colors of dark purple, forest green, and raspberry
CIRCA 1980

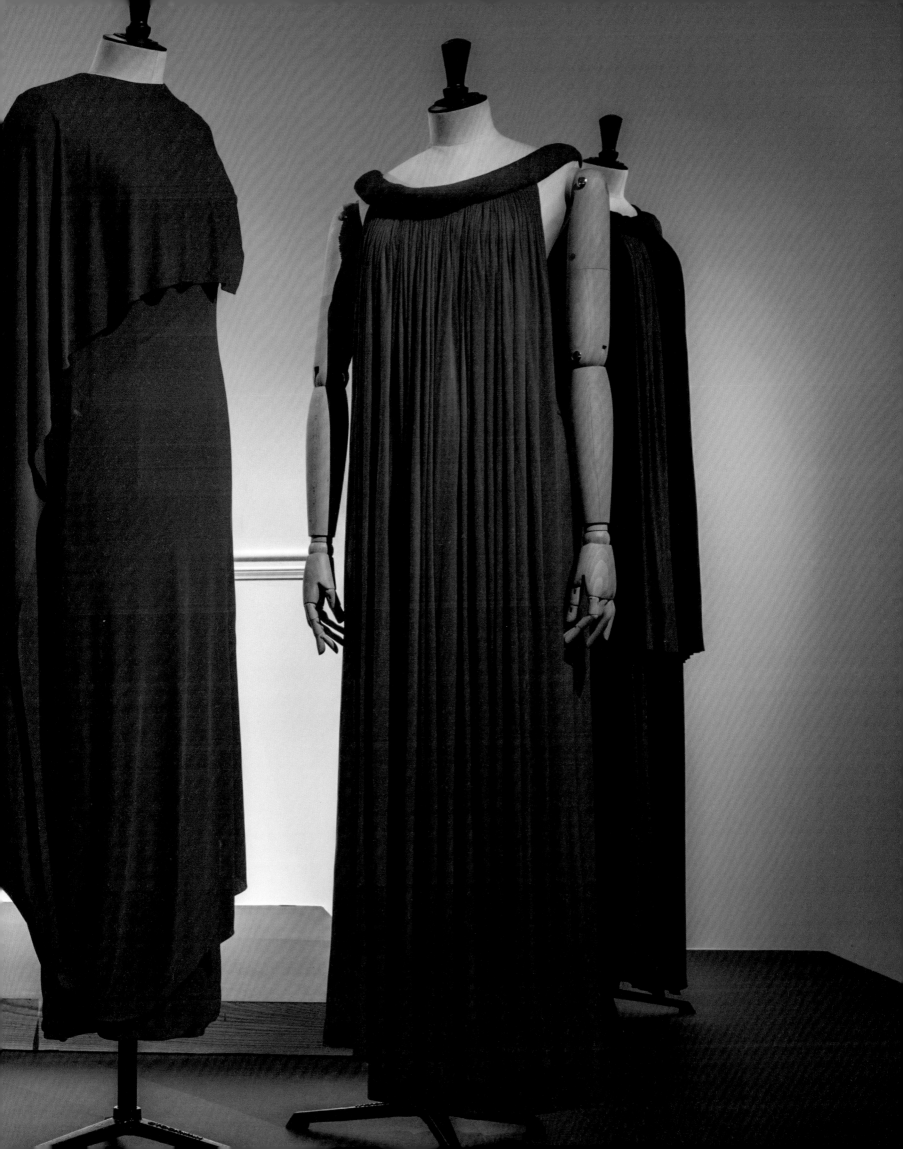

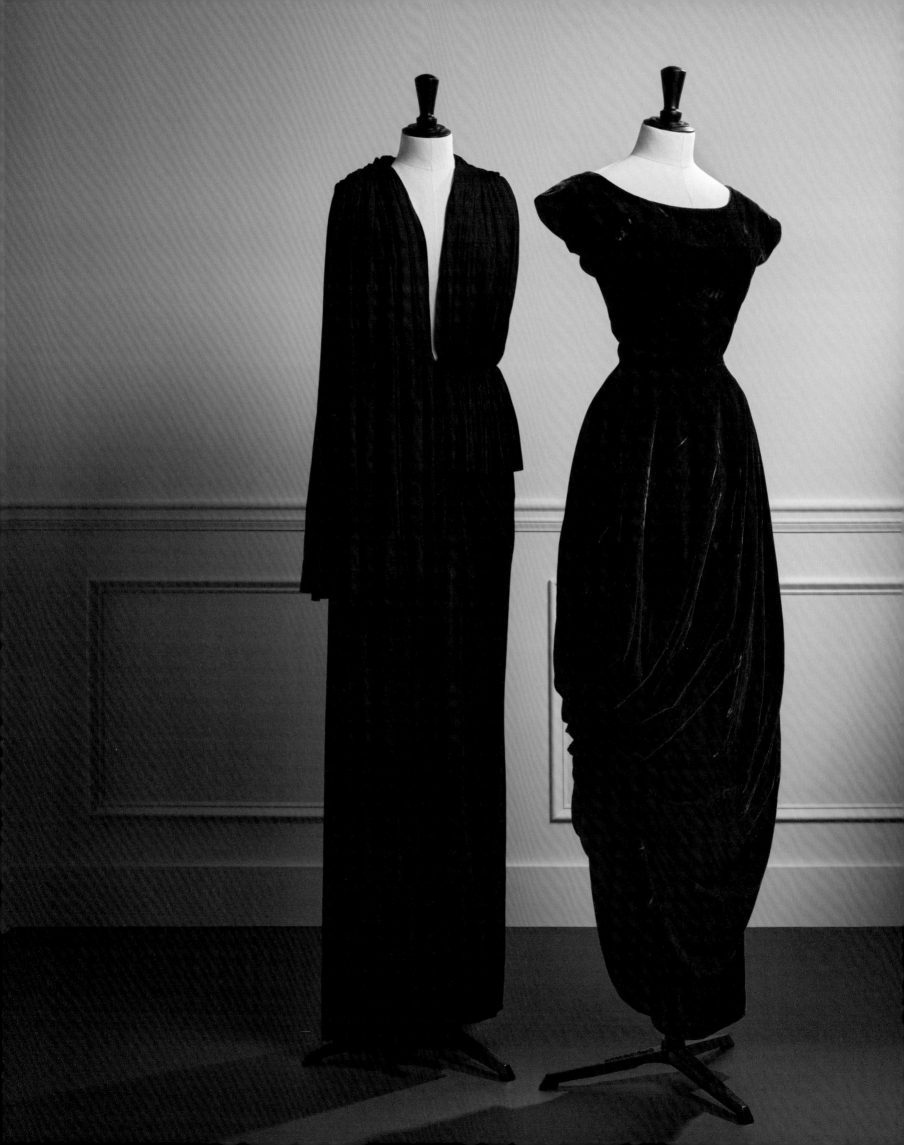

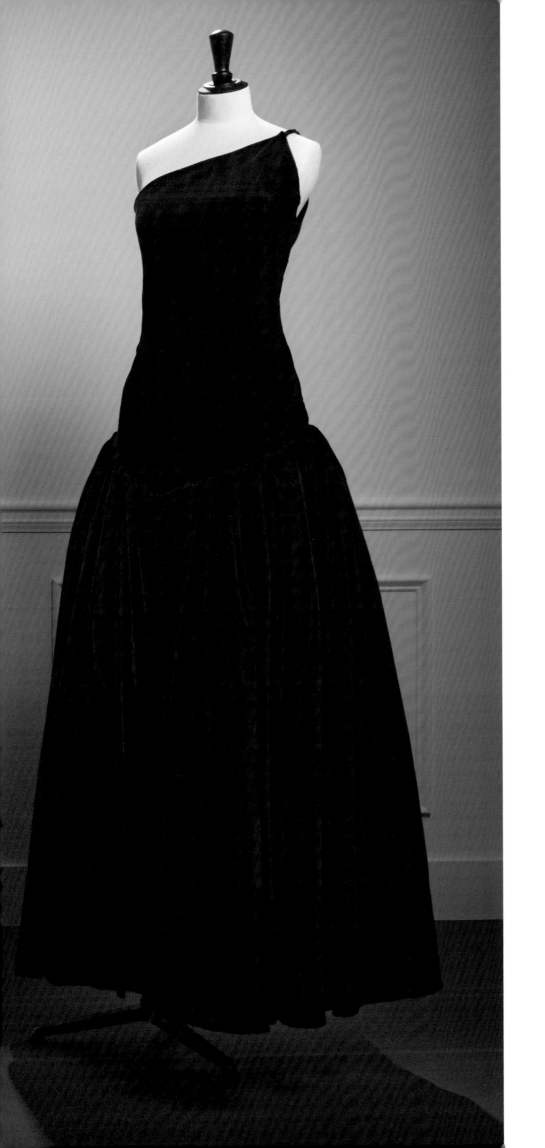

*Evening dress in imperial-red silk jersey
with deep-V neckline*
FALL-WINTER 1984-1985

Cocktail dress in imperial-red silk velvet
1957

*Asymmetrical evening dress
in burgundy silk velvet*
CIRCA 1961

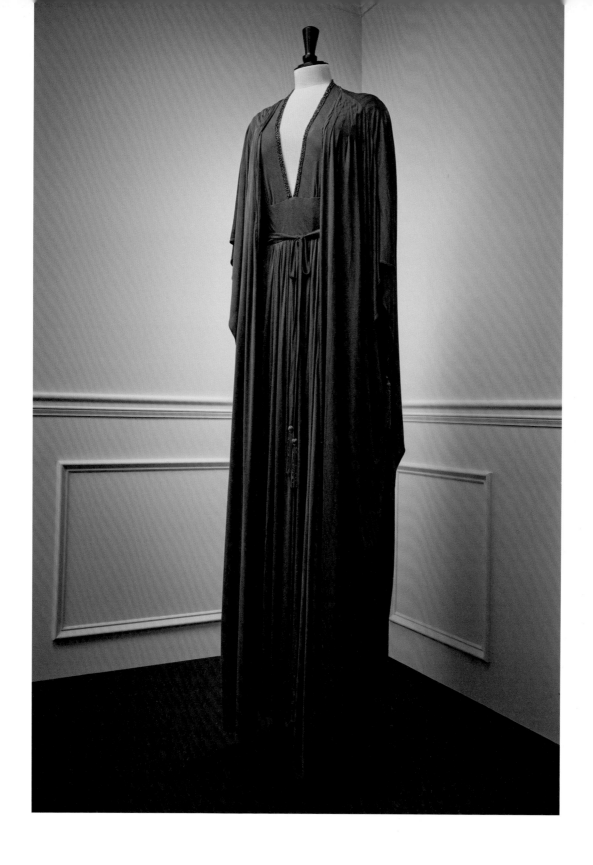

ABOVE

*Dark grey silk jersey cape jacket
and evening dress, grey-beaded embroidery,
belt at the waist with beaded-fringe trimming*
CIRCA 1980

OPPOSITE

*Stage costume in burgundy silk jersey, wrap
neckline with low cowl draping in the back*
CIRCA 1937

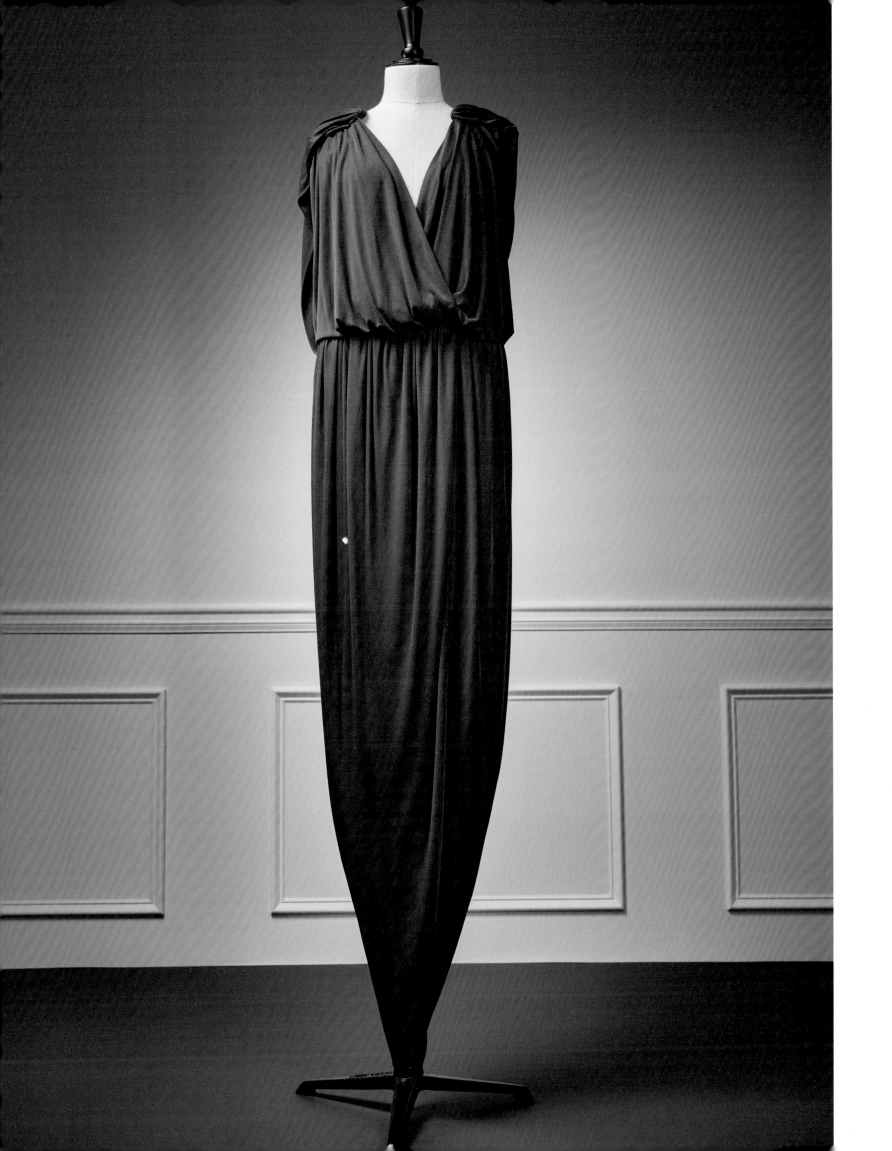

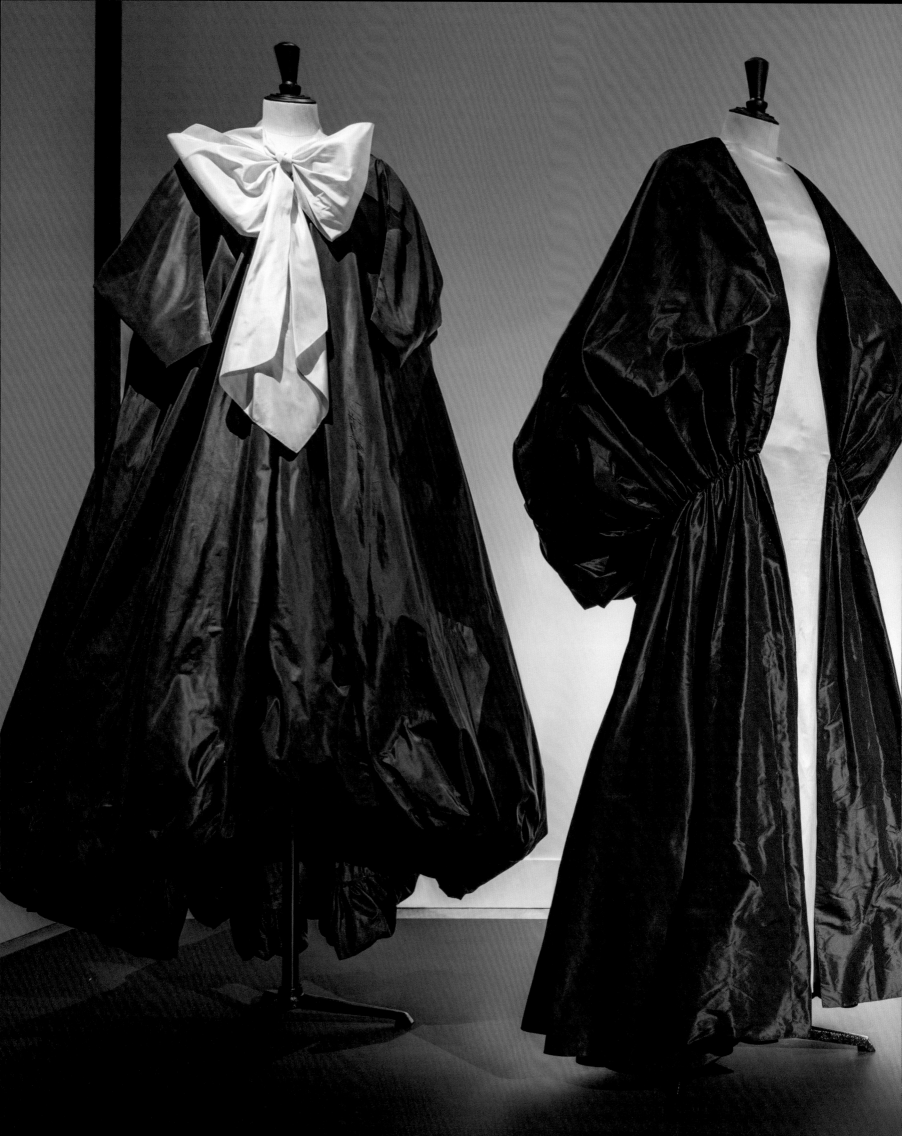

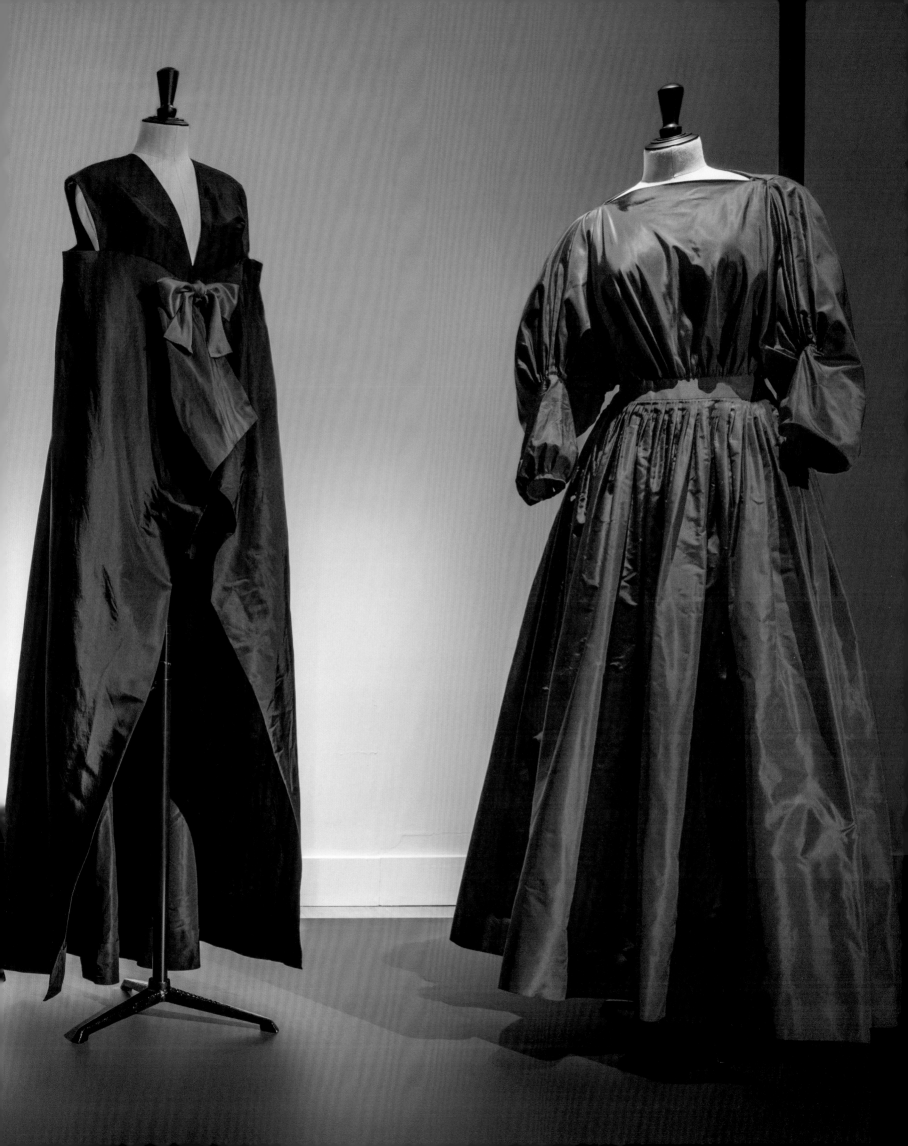

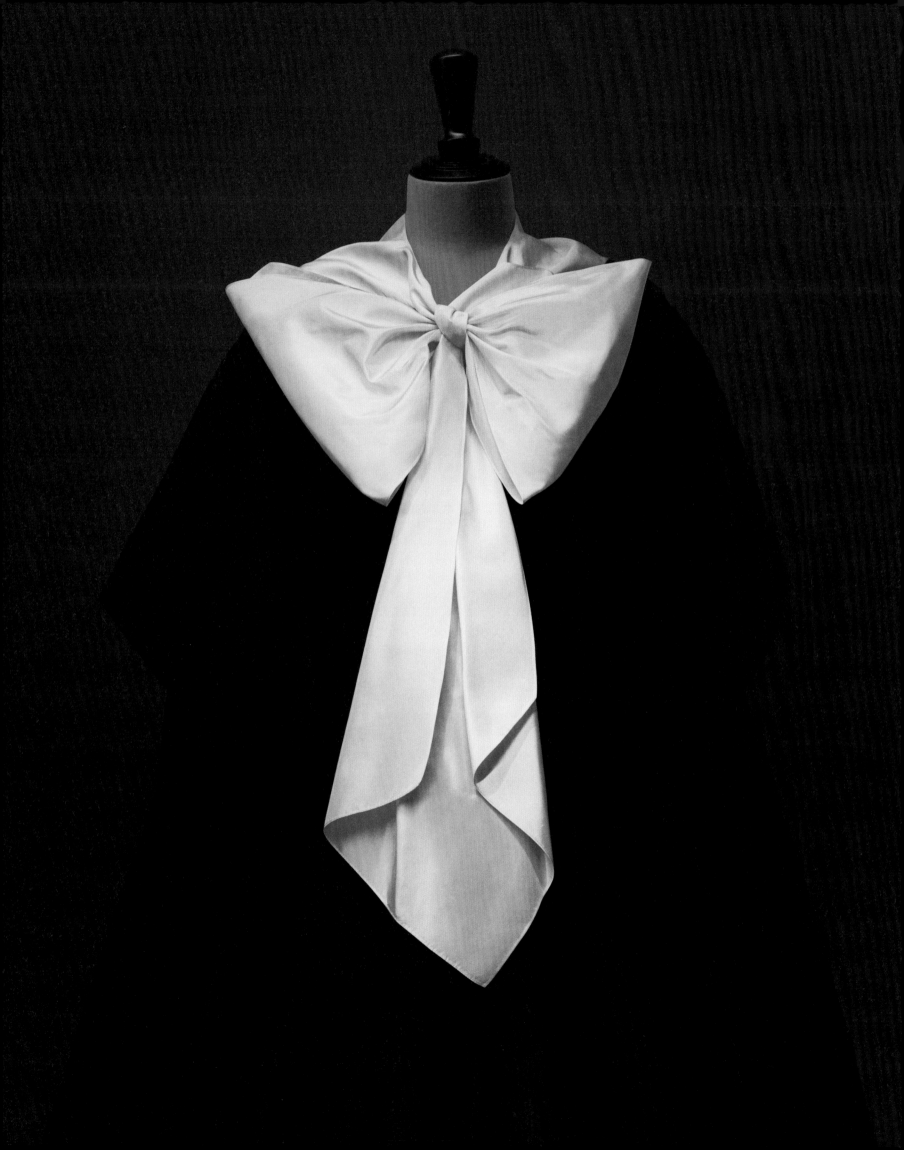

Evening dress in dark brown silk taffeta
with off-white tie collar
FALL-WINTER 1977-1978

Evening dress in ivory silk duchess satin
and burgundy taffeta
SPRING-SUMMER 1987

Evening dress in black faille with tied bow
in grenadine silk satin
SPRING-SUMMER 1977

Evening dress in scarlet-red silk taffeta
FALL-WINTER 1976-1977

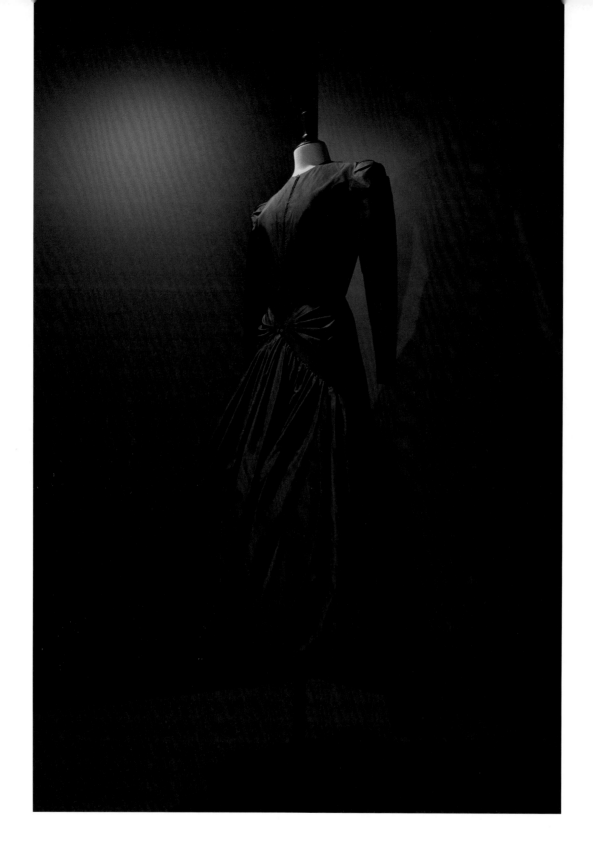

ABOVE

*Dress in black silk taffeta with sarouel panels
lined with raspberry silk taffeta*
CIRCA 1981

OPPOSITE, FROM LEFT TO RIGHT

*Long dress in black-moiré silk with a small
Italian collar neckline*
CIRCA 1935

*Long evening dress in black embossed
silk faille*
1935

*Cocktail dress in black silk taffeta with small
shawl collar*
FALL-WINTER 1951-1952

48

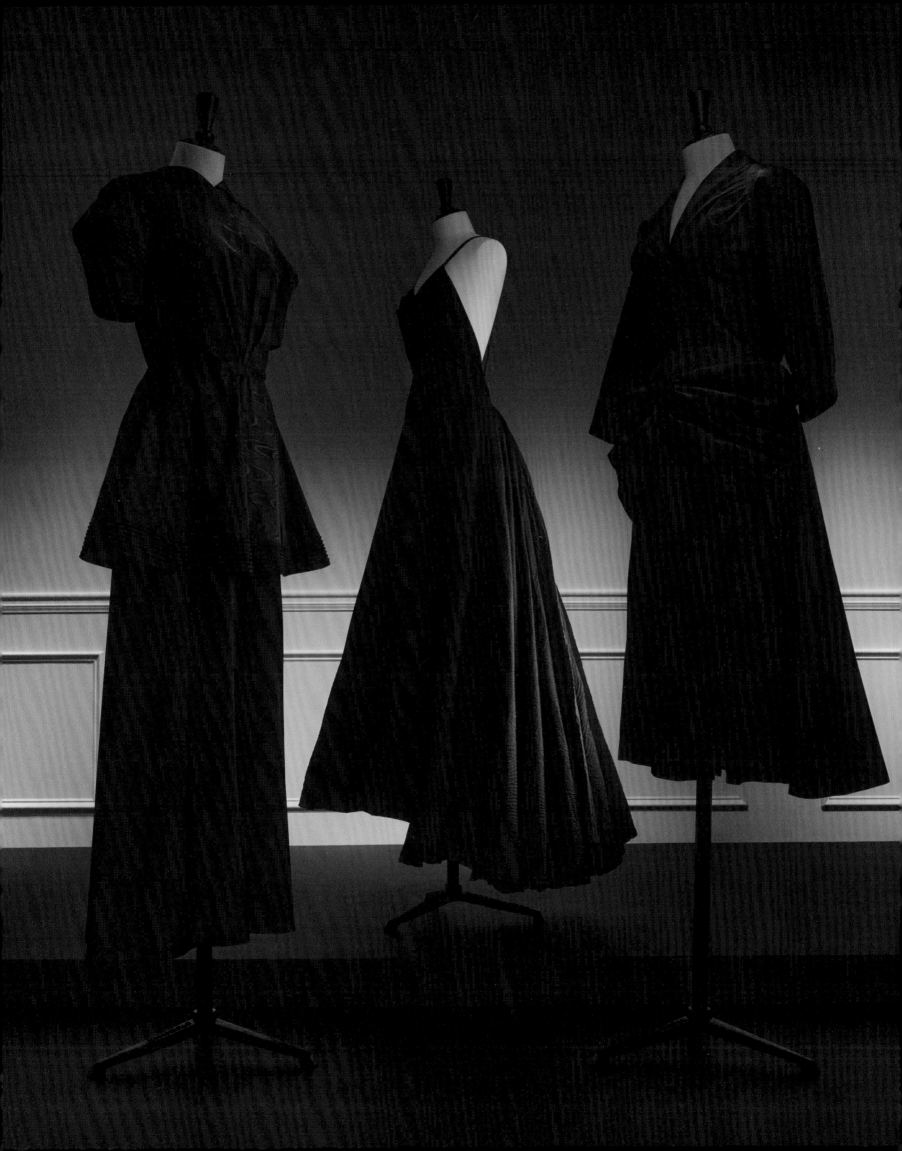

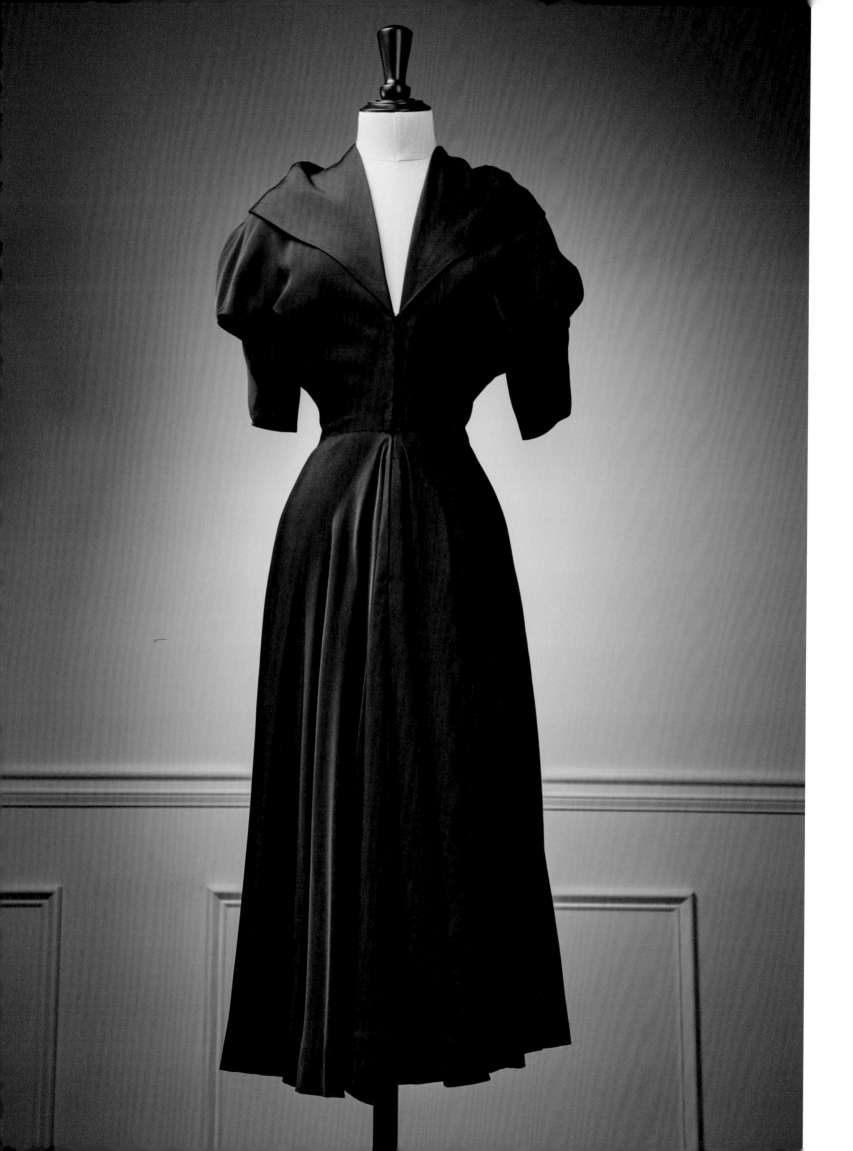

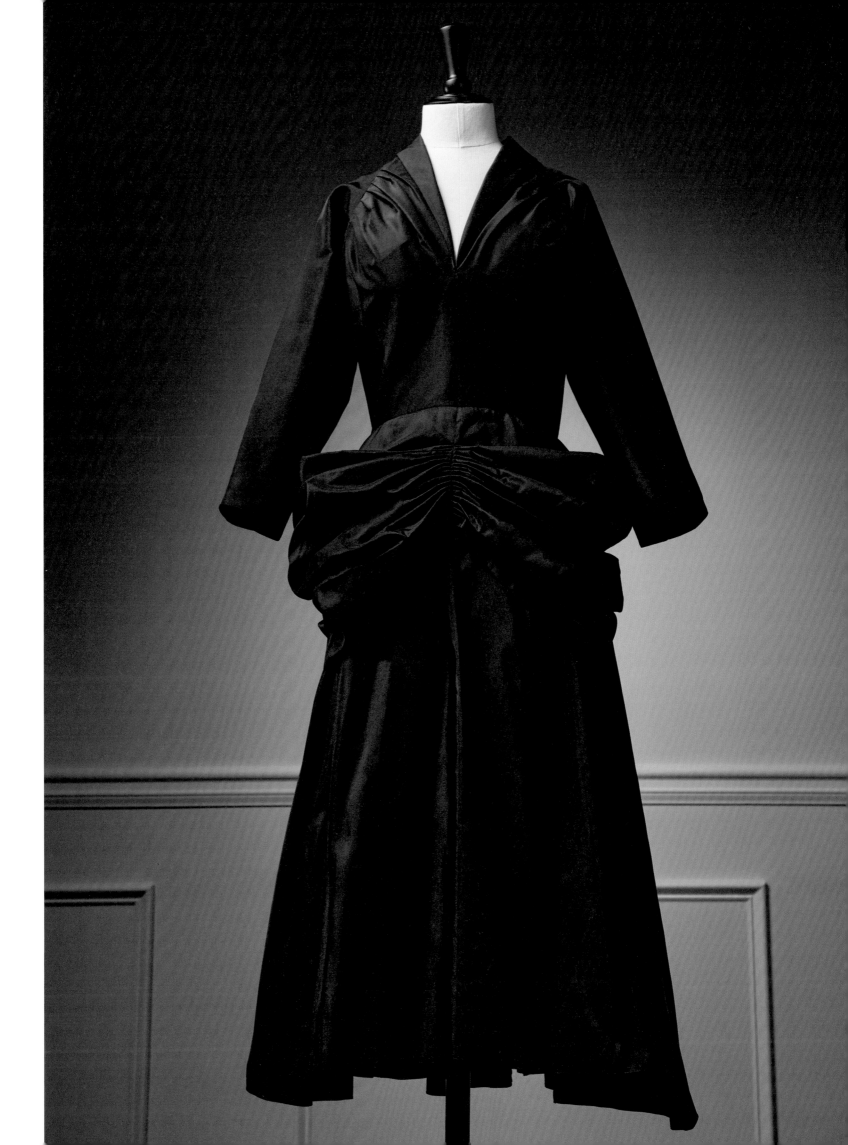

PREVIOUS PAGES

LEFT

*Afternoon dress in black ottoman silk,
large shawl collar*
CIRCA 1949

RIGHT

*Cocktail dress in back silk taffeta
with small shawl collar*
FALL-WINTER 1951-1952

OPPOSITE

*Antiquity-inspired evening dress
in blue silk jersey, draped neckline*
FALL-WINTER 1983-1984

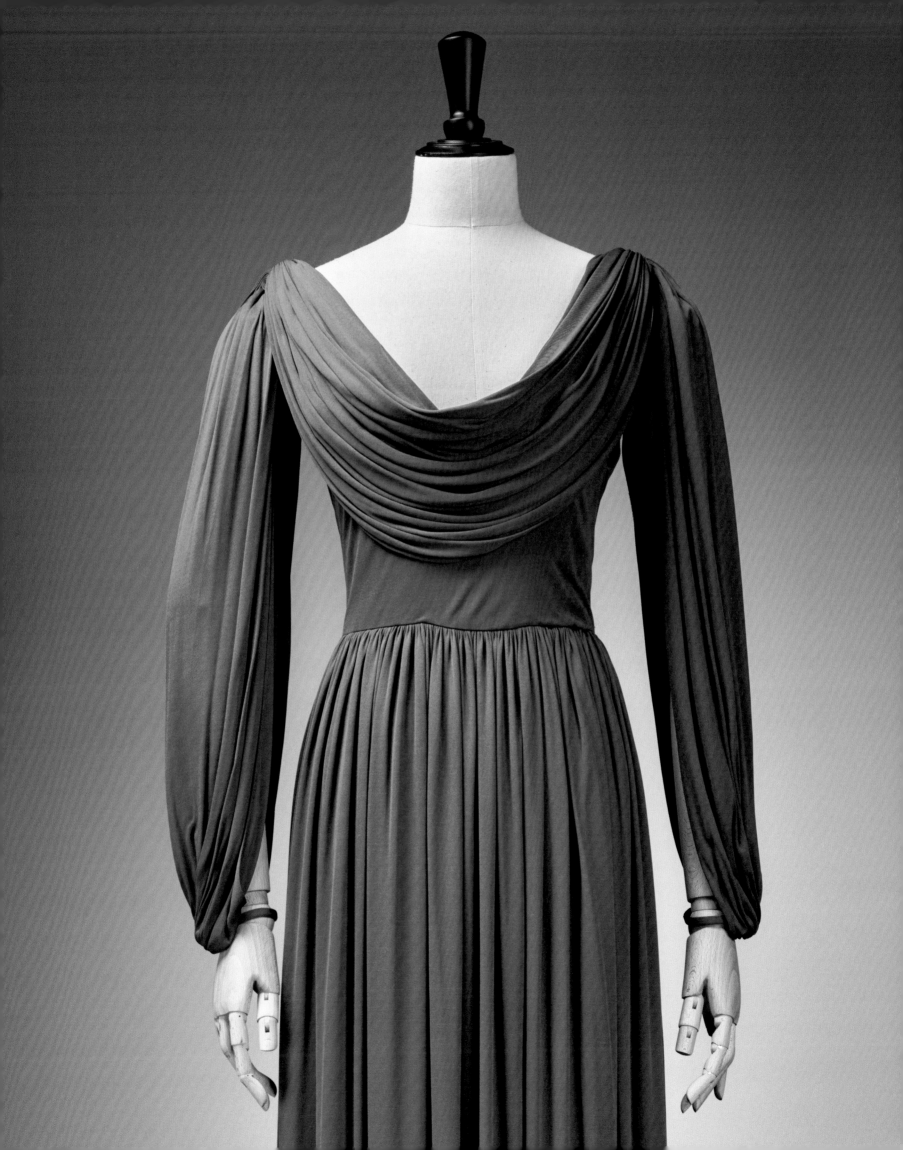

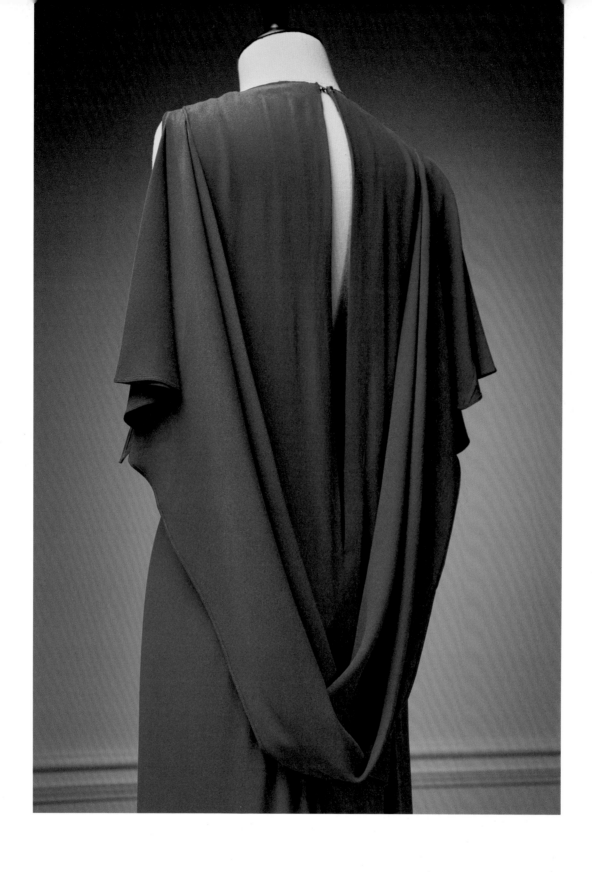

Evening dress in lapis-blue crepe de chine

Evening dress in royal-blue silk jersey, boat neckline, draped at the front and at the back

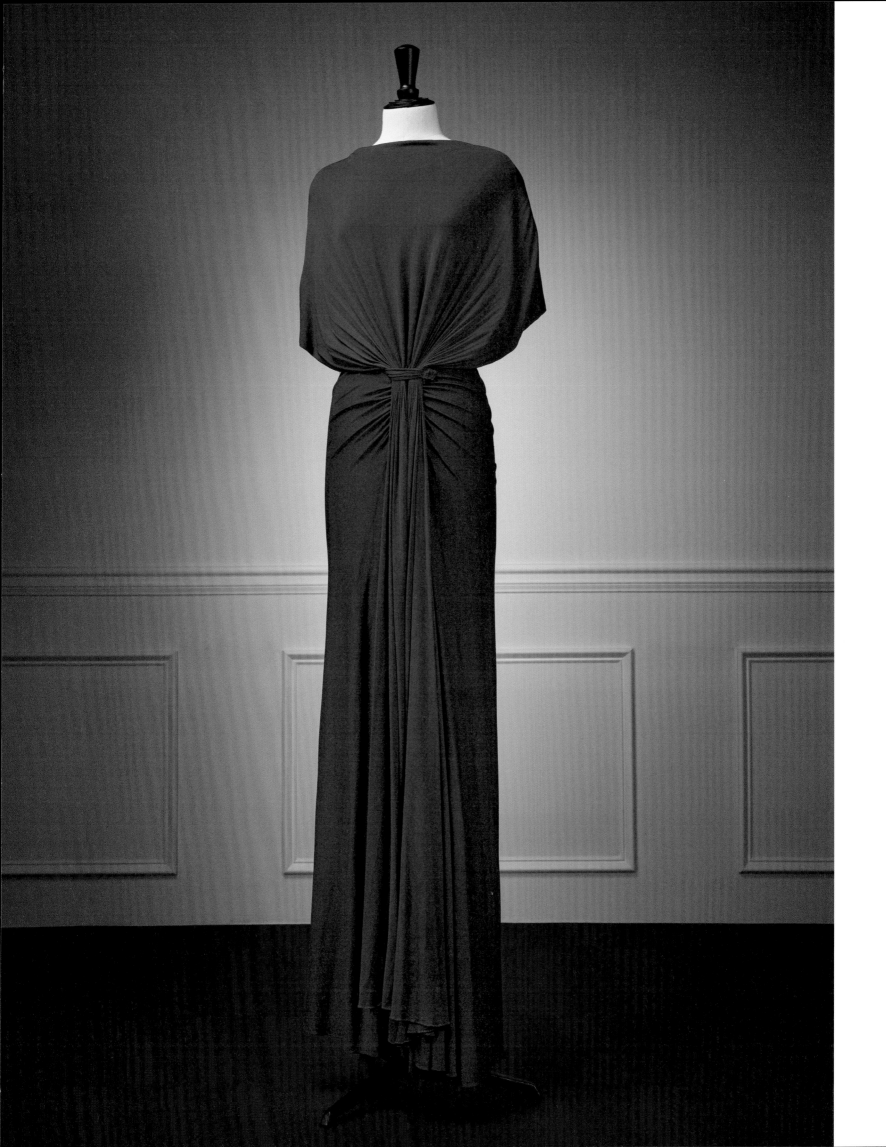

Evening dress in olive-green silk jersey,
draped from a strap in light-pink satin ribbon
SPRING-SUMMER 1975

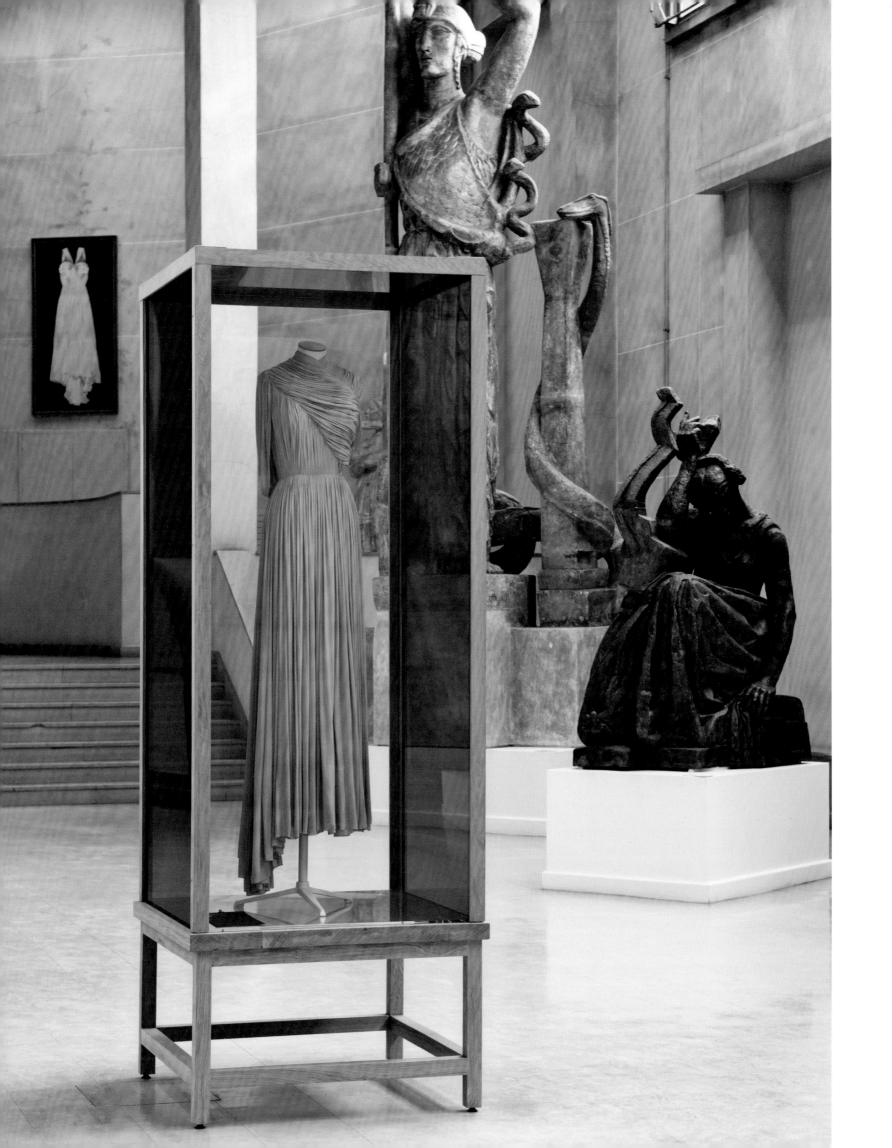

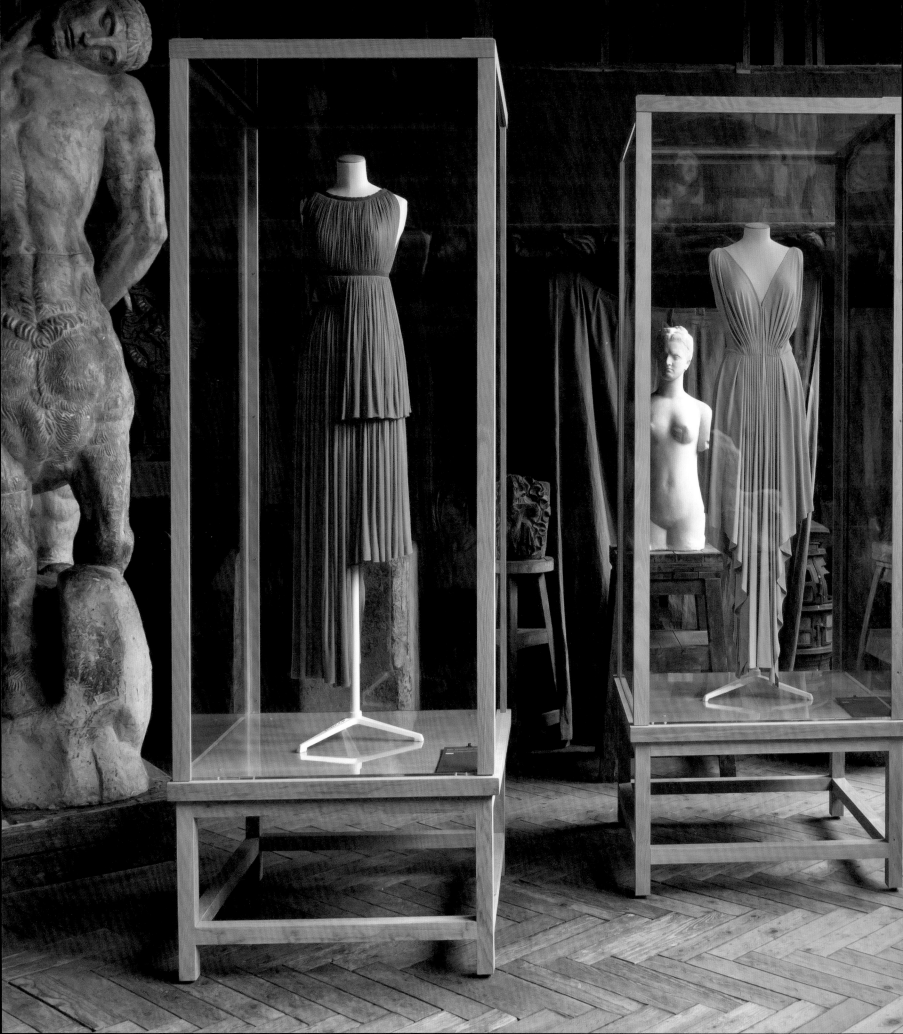

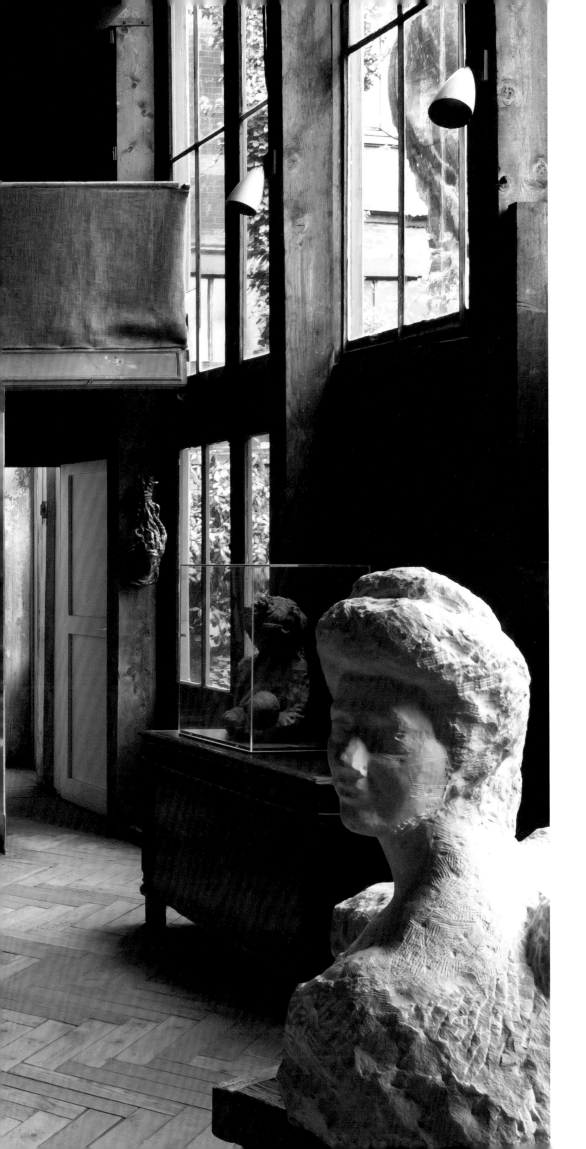

*Evening dress in orange silk jersey
from Racine*
SPRING-SUMMER 1977

Evening dress
BETWEEN 1981 AND 1986

73

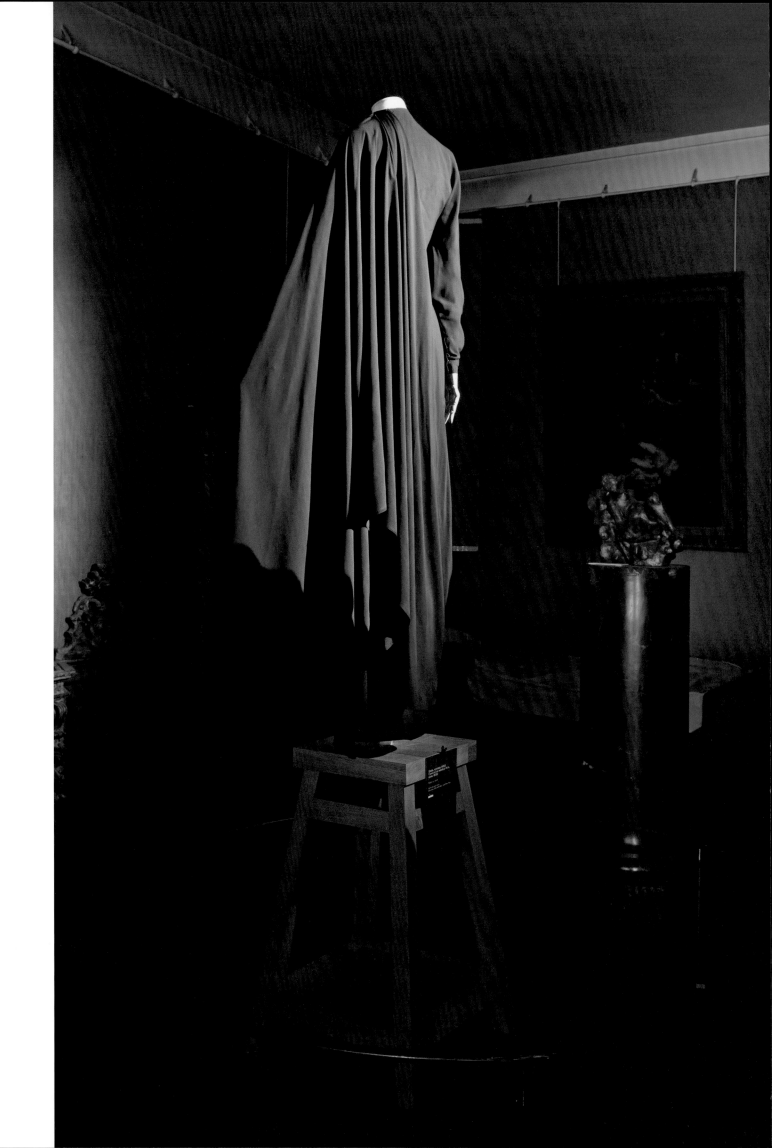

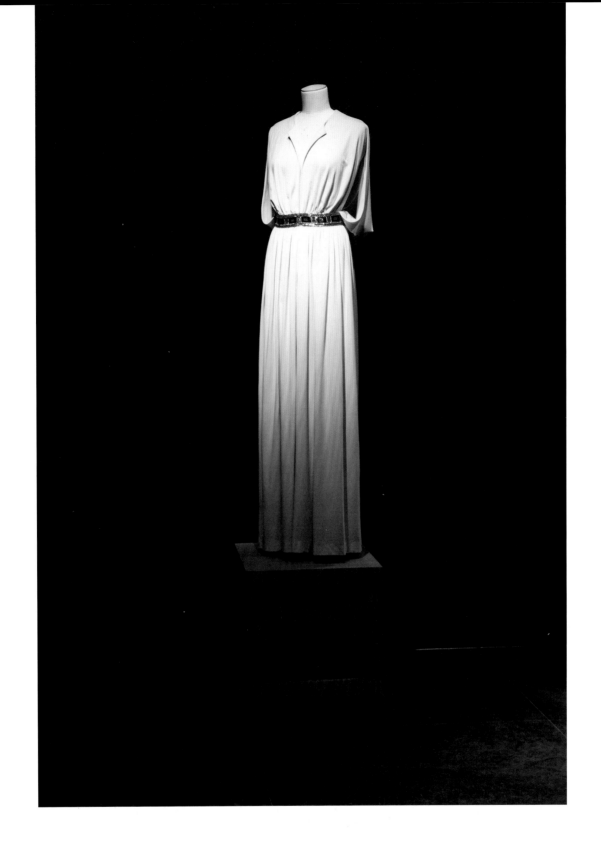

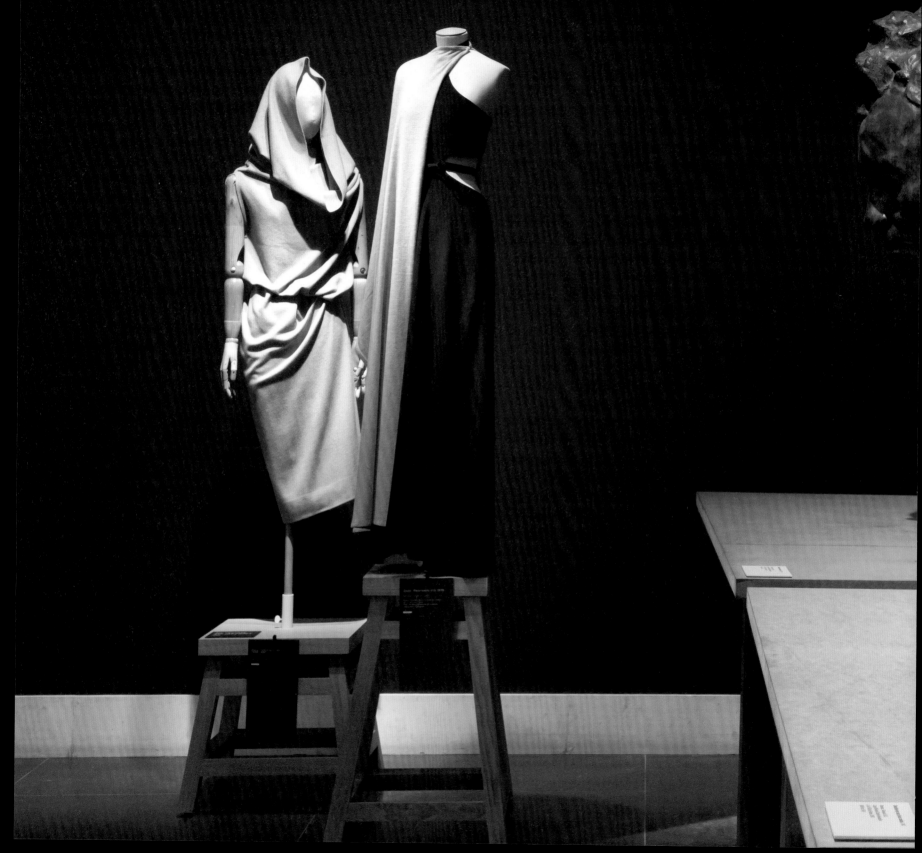

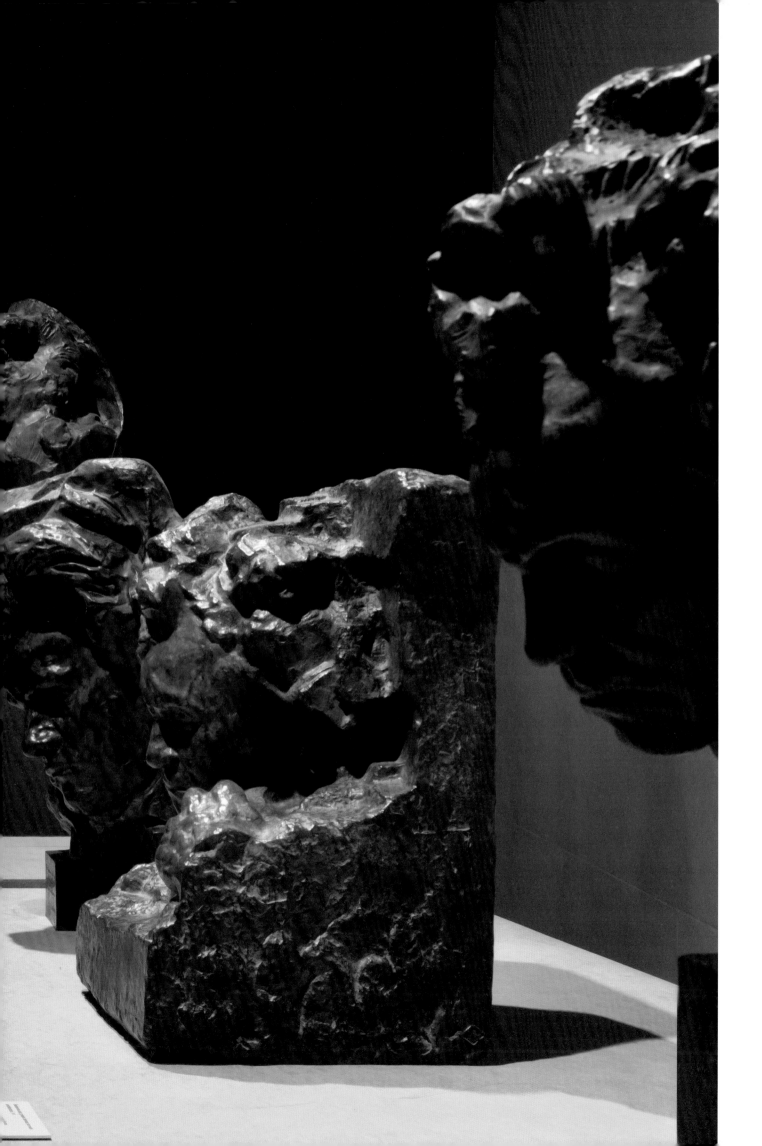

PREVIOUS PAGES, FROM LEFT TO RIGHT

Tube dress in old-rose wool jersey
FALL-WINTER 1986-1987

Evening dress and cape
SPRING-SUMMER 1976

OPPOSITE
Evening dress in black viscose jersey
CIRCA 1949

78

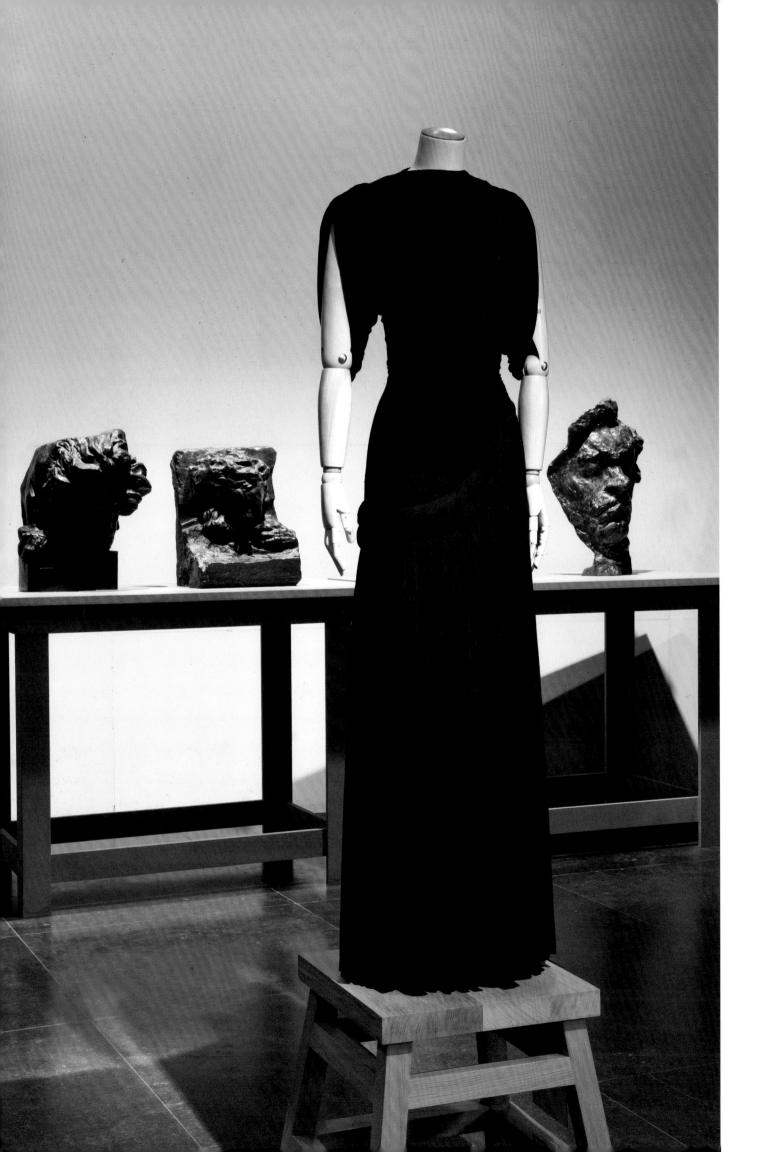

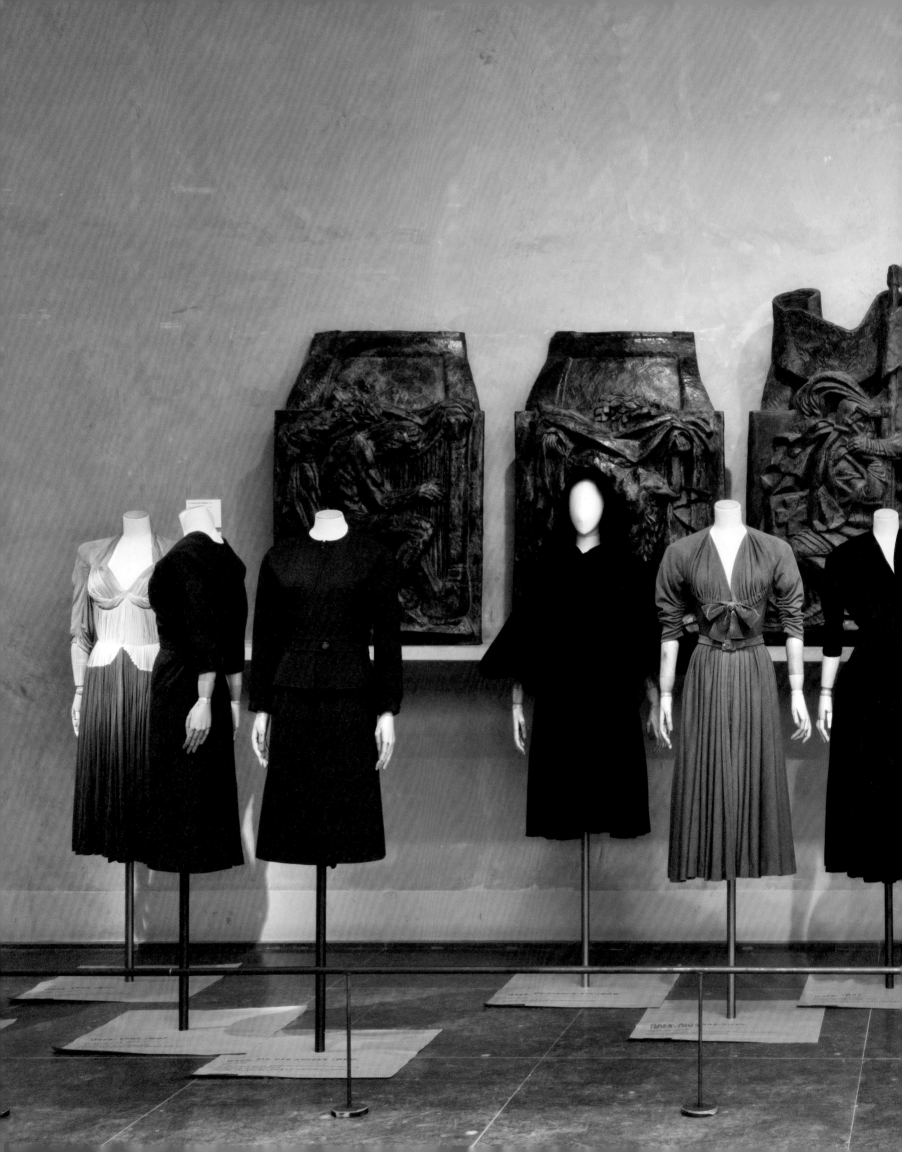

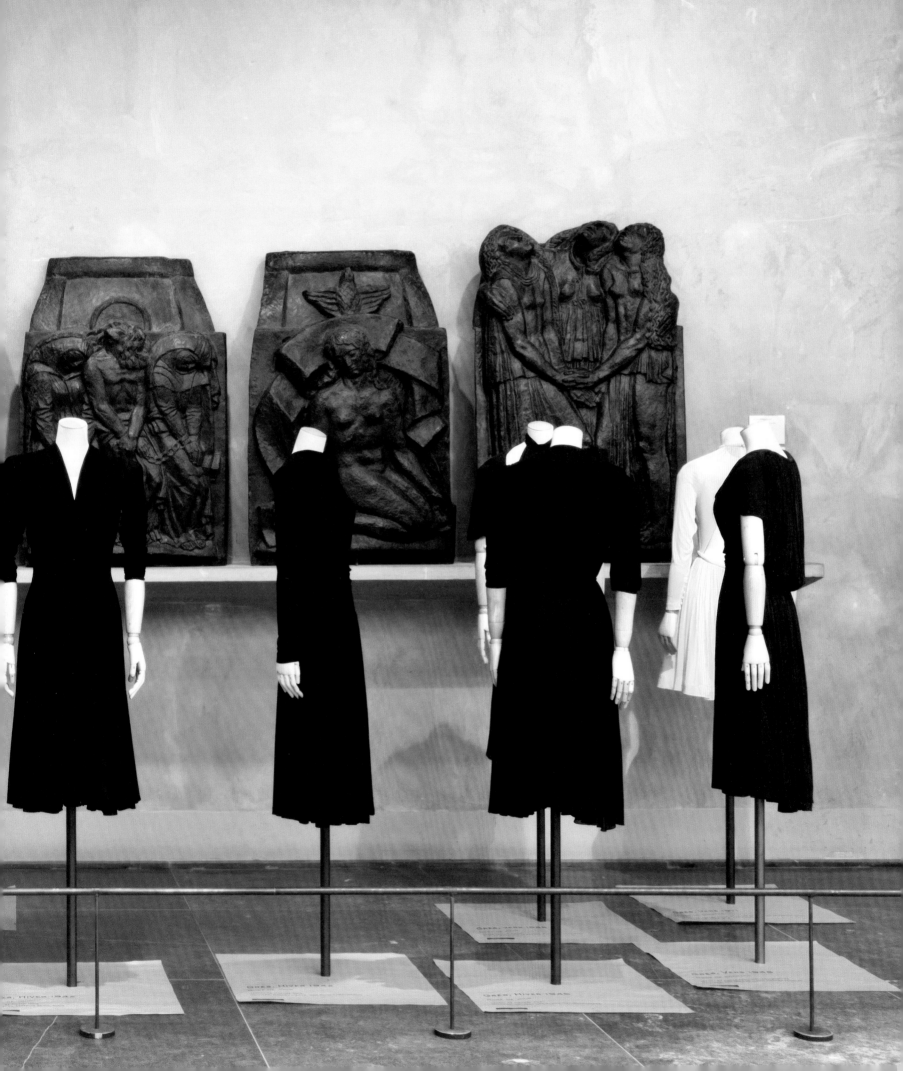

PREVIOUS PAGES, FROM LEFT TO RIGHT

*Formal day dress in almond-green
and dark-green viscose jerseys*
CIRCA 1945

Daywear ensemble, jacket and dress
BETWEEN 1946 AND 1956

Suit worn by the Duchess of Windsor
CIRCA 1970

Day coat in thick black wool
FALL-WINTER 1946-1947

*Day dress in grey wool jersey
with a rosewood velvet bow*
FALL-WINTER 1953-1954

Cocktail dress in black panne velvet
CIRCA 1947

Cocktail dress in black silk jersey
FALL-WINTER 1942

Formal dress
FALL-WINTER 1942

*Formal dress in black viscose jersey,
seen from the back*
FALL-WINTER 1945

Formal dress, seen from the side
CIRCA 1950

Cocktail dress in yellow viscose jersey
CIRCA 1971

OPPOSITE, FROM LEFT TO RIGHT

*Evening dress in bright-green, red, purple
and yellow silk jersey strips from Racine*
SPRING-SUMMER 1976

*Evening ensemble, asymmetrical cape
and dress*
CIRCA 1980

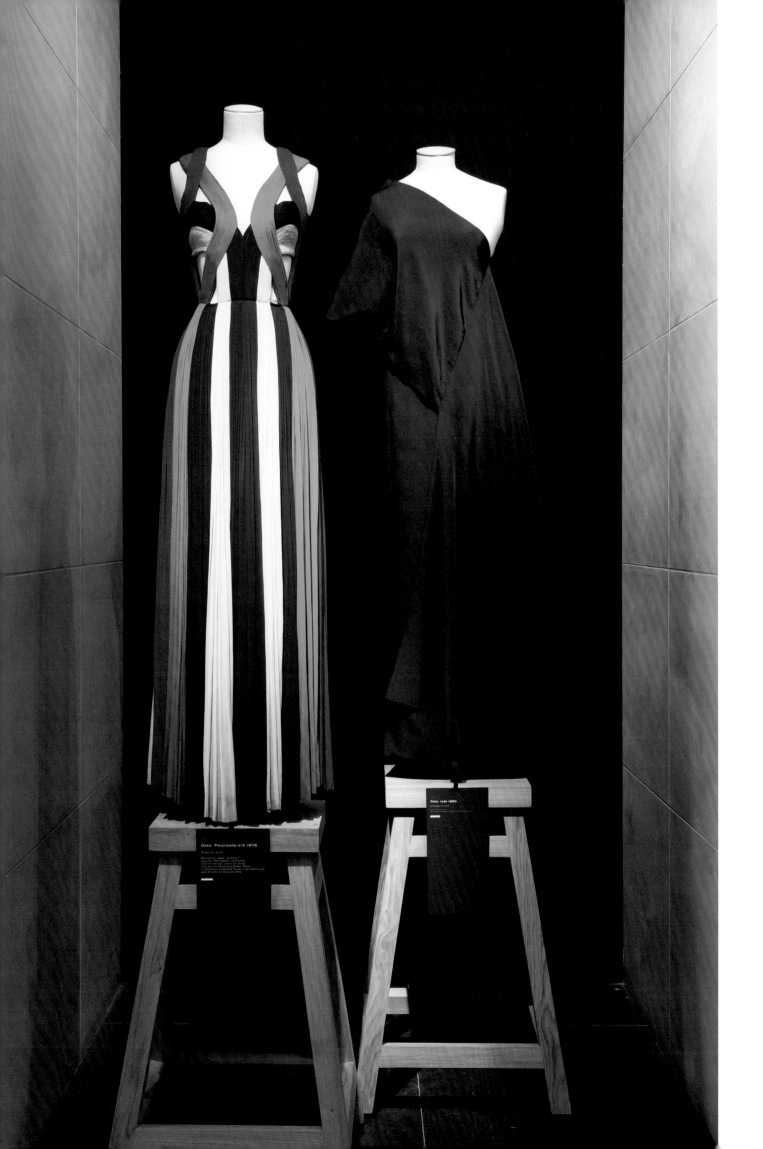

84

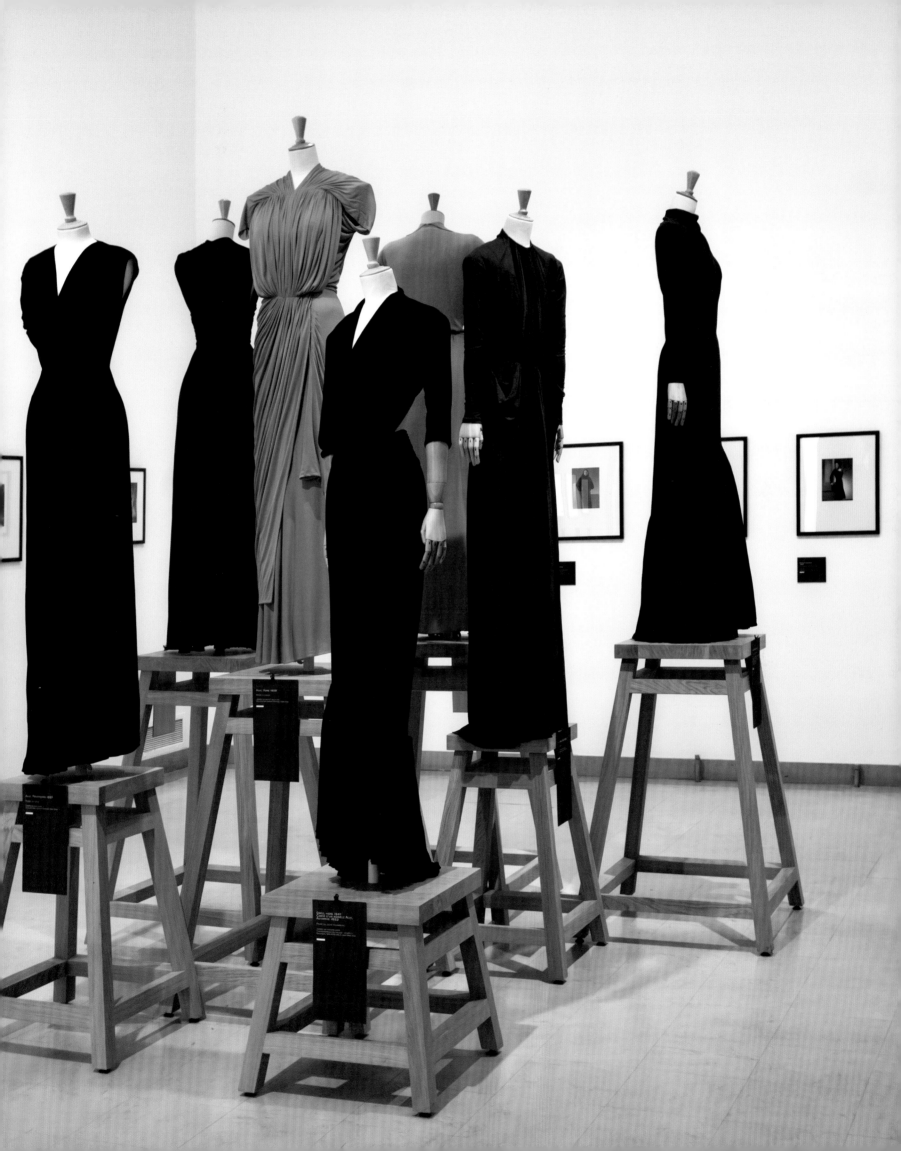

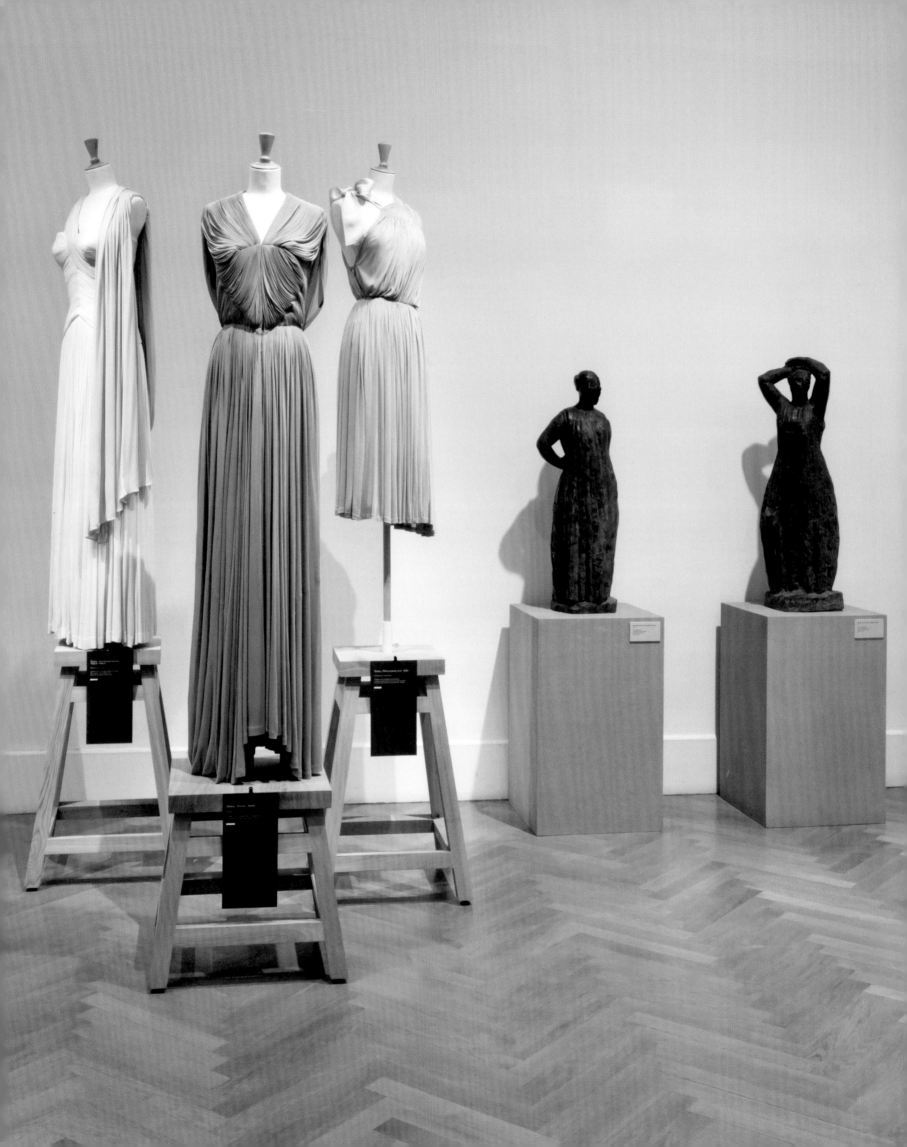

*Evening dress in white
and grey viscose jerseys*
FALL-WINTER 1955

Evening dress in periwinkle viscose jersey
WINTER 1945

*Cocktail dress in pearl-grey viscose jersey,
large ribbon in ivory silk faille*
SPRING-SUMMER 1951

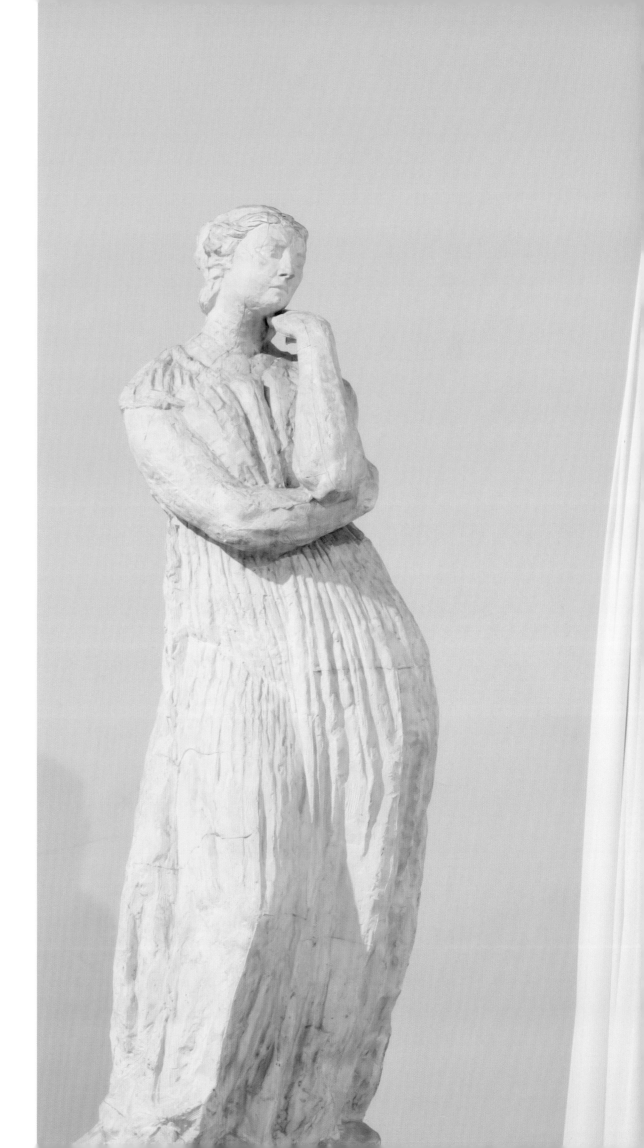

MADAME GRÈS

BIOGRAPHY

1903 Germaine Émilie Krebs is born on 30 November in the Ternes neighborhood of Paris's 17th arrondissement.

CA. 1915 Germaine dreams of becoming a sculptor. Her father refuses but allows her to attend classes in drawing and then sewing, which lead her to discover a passion and vocation for fabrics and clothing.

CA. 1920 Still a minor, Germaine leaves the family home. She learns how to cut fabrics and starts to work in the millinery department at Le Bon Marché department store.

1924 The budding couturier joins the Premet couture house on Place Vendôme as an assistant. She would subsequently be promoted to second and then first *modéliste* (designer-patternmaker) in the late 1920s.

1930 Germaine Krebs makes her first pieces in her small Paris apartment, which she goes on to present in person to agents in the Folies Bergère neighborhood. Germaine Krebs becomes "Alix" and joins Alex Couture at 8 rue de Miromesnil.

1933 Alex Couture is taken over by Julie Barton, an actress turned couturier. Alix and Barton join forces and found the Alix Barton couture house. Its opening attracts attention, and success comes quickly. The fashion magazine *L'Officiel de la couture et de la mode* publishes a portrait of the woman who now styles herself as Mademoiselle Alix, together with an Alix Barton outfit from the Spring 1933 collection.

1934 Alix Barton creations are exported across the Atlantic thanks to buyers from Macy's department stores. Following the announcement of Julie Barton's departure, Alix Barton becomes Maison Alix. At the age of 30, Alix leaves rue de Miromesnil to set up shop under her own name at 83 rue du Faubourg Saint-Honoré.

1935 The couturier creates the costumes for a production of Jean Giraudoux's play *La guerre de Troie n'aura pas lieu* directed by Louis Jouvet. *Vogue* praises the outfits, calling them both modern and au courant.

1937 Germaine Krebs marries the Russian painter Serge Anatolievich Czerefkov, known as Grès, whom she met at one of his exhibitions in 1934. That same year, she is awarded the top prize in the Couture category at the 1937 International Exposition of Art and Technology in Modern Life. Marlene Dietrich becomes a loyal customer of the couture house.

1938 Despite serving as creative director, she is on salary and not paid well. Madame Grès threatens to quit her own couture house. She negotiates and ultimately obtains half of the shares in the business.

1939 Madame Grès gives birth to the couple's first and only child, Anne Muni Jacqueline Czerefkov.

1940 In the summer, as German troops approach the capital, Madame Grès leaves Paris with her daughter and parents. They go to stay at Saint-Béat in the French Pyrenees, where the couturier continues to design pieces.

1942 In the spring, Madame Grès is denounced, probably by one of Maison Alix's investors, as a Jew to the occupying authorities. She sells her shares in the business but Lucien Lelong, president of the trade association Chambre Syndicale de la Couture Parisienne, persuades her not to abandon the profession. The House of Grès opens its doors on August 1, 1942, at 1 rue de la Paix.

1944 In January, the Vichy government orders the House of Grès's workshops to be shut down, by way of an example. Thanks to active support from artists such as Jean Cocteau and Christian Bérard, the couture house is back in action in March, on the condition that Madame Grès adapt her technique of draping, which is contrary to the fabric restrictions imposed by the occupying authorities.

1945 The House of Grès takes part in the *Théâtre de la mode* touring exhibition alongside the great designers of the period. Together, Madame Grès and Elsa Schiaparelli create María Casares's costumes for Robert Bresson's film *Les Dames du Bois de Boulogne*.

1949 Madame Grès is awarded the Légion d'Honneur.

Alix (Madame Grès) adjusts a dress on a model
BORIS LIPNITZKI, 1933

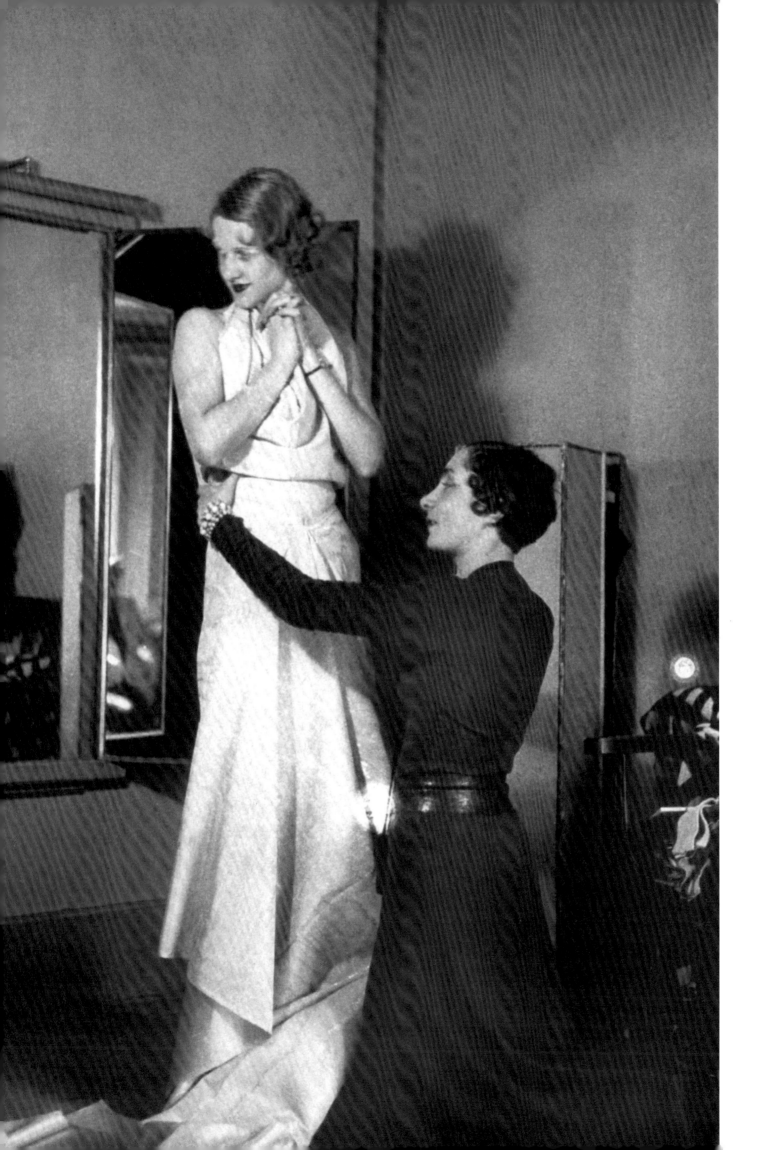

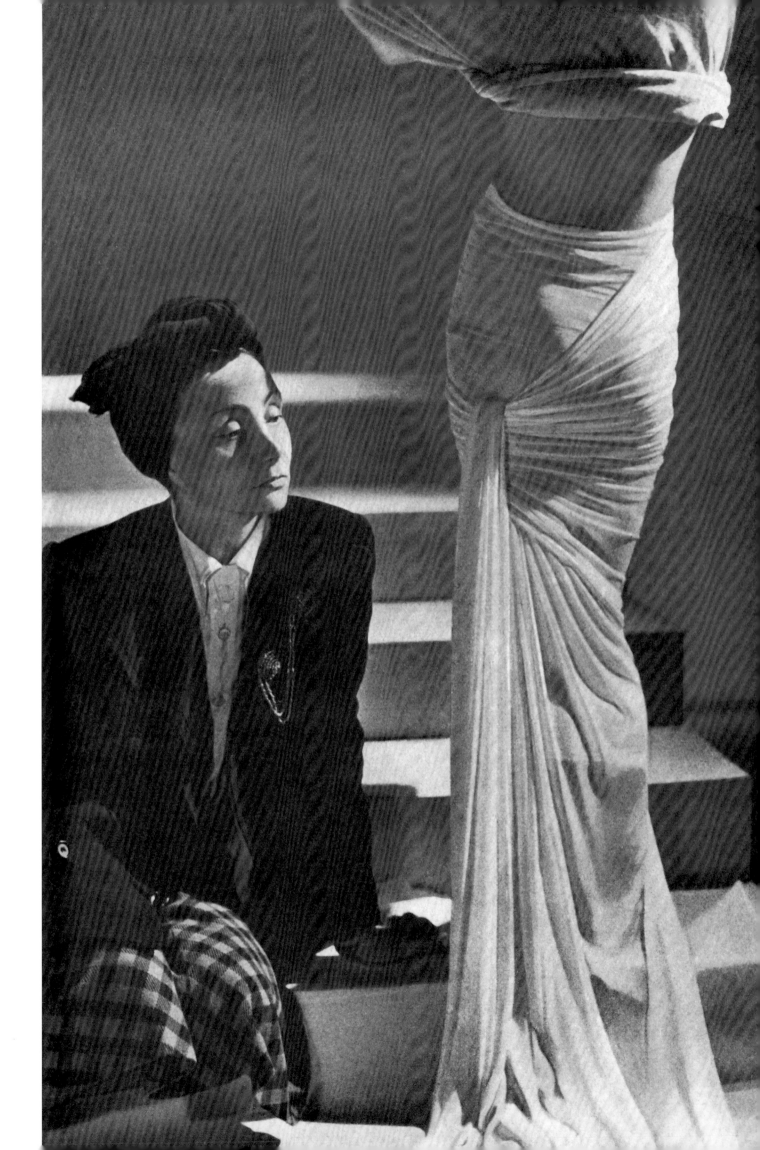

1954 The Ford Foundation sends Madame Grès on a mission to India to study the country's textile crafts. The influence of Indian clothing would be felt in some of her later creations.

She makes the actress Silvana Mangano's costumes for her roles as Circe and Penelope in Mario Camerini's *Ulysses*.

1959 The House of Grès launches its first perfume, *Cabochard* ("Pigheaded"), a playful reference to Madame Grès's cantankerous personality. The scent remains a resounding success for several decades.

1960s A high point for her collaboration with major fashion magazines such as *Vogue* and *L'Officiel*, captured through the lenses of the era's greatest photographers including Irving Penn and Richard Avedon.

1962 Launch of Grès Mademoiselle by Madame Grès, a more affordable range than her haute couture creations and aimed at a younger clientele.

1965 Madame Grès's daughter gets married in a dress designed by her.

1966 Madame Grès's creations follow along with the Swinging Sixties. She lends a bridal gown to William Klein for his film *Who Are You, Polly Maggoo?*, a satire on the fashion world. Among her couture house's customers are Jackie Kennedy, Grace Kelly, Begum Aga Khan, and the Duchess of Windsor. In the same year, Madame Grès becomes a grandmother.

1970 Madame Grès is unanimously elected president of the Chambre Syndicale de la Haute Couture. Her husband dies in Tahiti.

1974 Having lost a lawsuit against the American distributor of *Cabochard*, Grès is ordered to pay the distributor ten million francs for "defective execution of a contract."

1976 A new success with the launch of the unisex fragrance, *Quiproquo*.
Madame Grès is awarded couture's first Dé d'Or (Golden Thimble), created by Cartier, for her Fall-Winter 1976–1977 collection.

1978 On October 8 in New York City, Madame Grès is awarded the Creative Leadership in the Art Profession Award; then, in December, she is awarded first prize, the Best, for talent and elegance by the Camera Nazionale dell'Alta Moda Italiana in Rome.

1979 Grès and Cartier join forces to launch the Grès-Cartier jewelry line.

Madame Grès, next to one of her models
EUGÈNE RUBIN, 1946

1980 As ready-to-wear begins to take precedence over haute couture, Madame Grès develops her first collection. The items for distribution based on her designs are produced by the stylist Peggy Huynh Kinh. Madame Grès is raised to the rank of *Officier* of the Légion d'Honneur.

1983 Madame Grès is made a *Commandeur* of the French Ministry of Culture's Ordre des Arts et des Lettres.

1984 Madame Grès enters into a partnership with Bernard Tapie, who buys up more than half of her business. He sets out to reorganize it and to diversify its activities.

1986 Financial problems continue to mount. The House of Grès is expelled from the Chambre Syndicale de la Haute Couture for failure to pay its dues. Even so, Madame Grès retains the honorary title of President. In September, the Bernard Tapie group sells its shares to Jacques Esterel. A period of litigation between the two groups ensues.

1987 Grès files for bankruptcy after two years of unpaid rent. The premises at 1 rue de la Paix are cleared and the assets sold off.

1988 The company is bought by the Japanese group Yagi Tsusho Limited, which remains its owner today. After presenting her final collection, for Spring-Summer 1988, Madame Grès withdraws from public life.

1990 Madame Grès and her daughter, Anne, leave Paris and go to live in the family home at Saint-Paul-de-Vence.

1992 The House of Grès moves to 422 rue du Faubourg Saint-Honoré.

1993 Madame Grès, again going by the name Germaine Grès, dies on November 24 in total solitude.

1994 From September 13 to November 27, the retrospective exhibition *Great Grès* is held at the Metropolitan Museum of Art, New York. The news of Madame Grès's death is not made public until December 14, 1994, on the front page of the French newspaper *Le Monde.*

2011 From March 25 to August 28, the Palais Galliera held an extra-mural exhibition *Madame Grès, la Couture à l'œuvre* at the Musée Bourdelle, in Paris.

2022-2023 From November 11, 2022 to July 2, 2023, a new retrospective exhibition *Madame Grès, The Art of Draping* is held at the SCAD FASH Museum of Fashion + Film, in Atlanta.

2023-2024 From September 11, 2023 to May 20, 2024, the Azzedine Alaïa Foundation, in Paris, helds the exhibition *Alaïa/Grès. Au-delà de la mode*.

Evening dress
ANONYMOUS

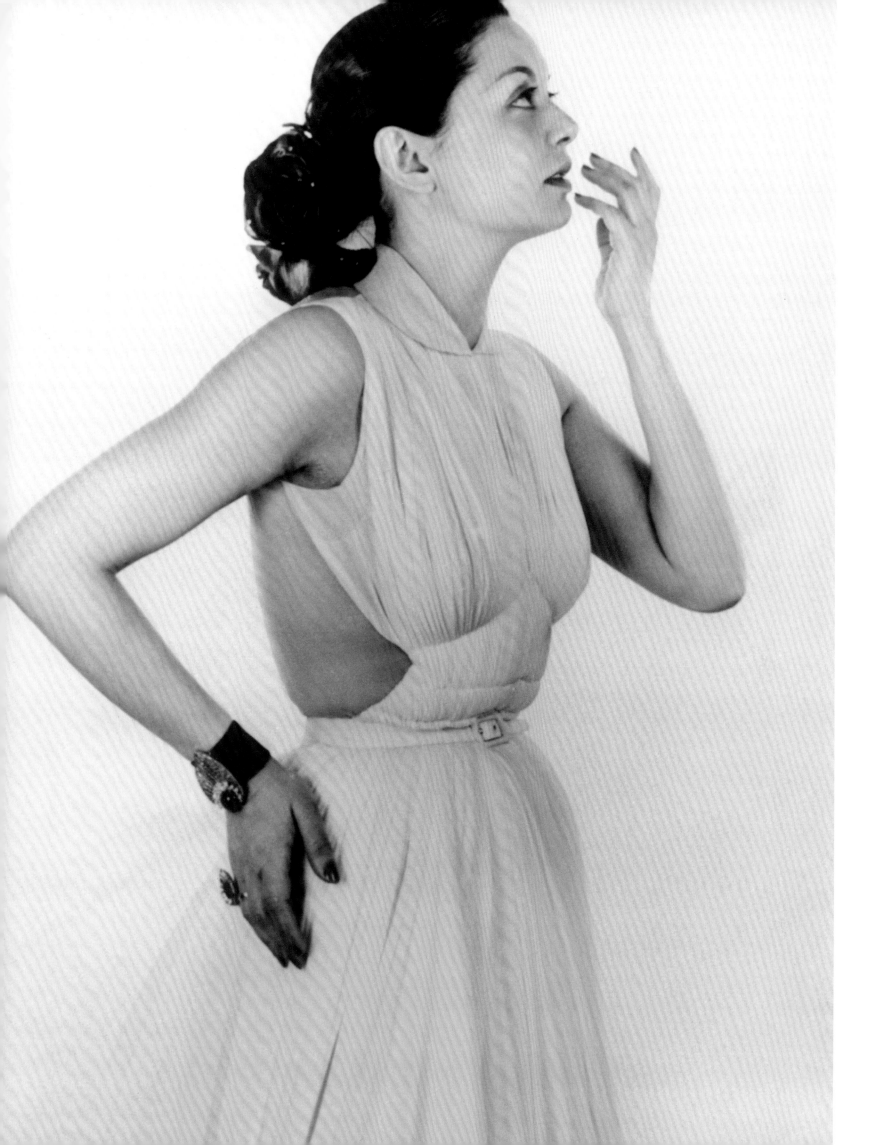

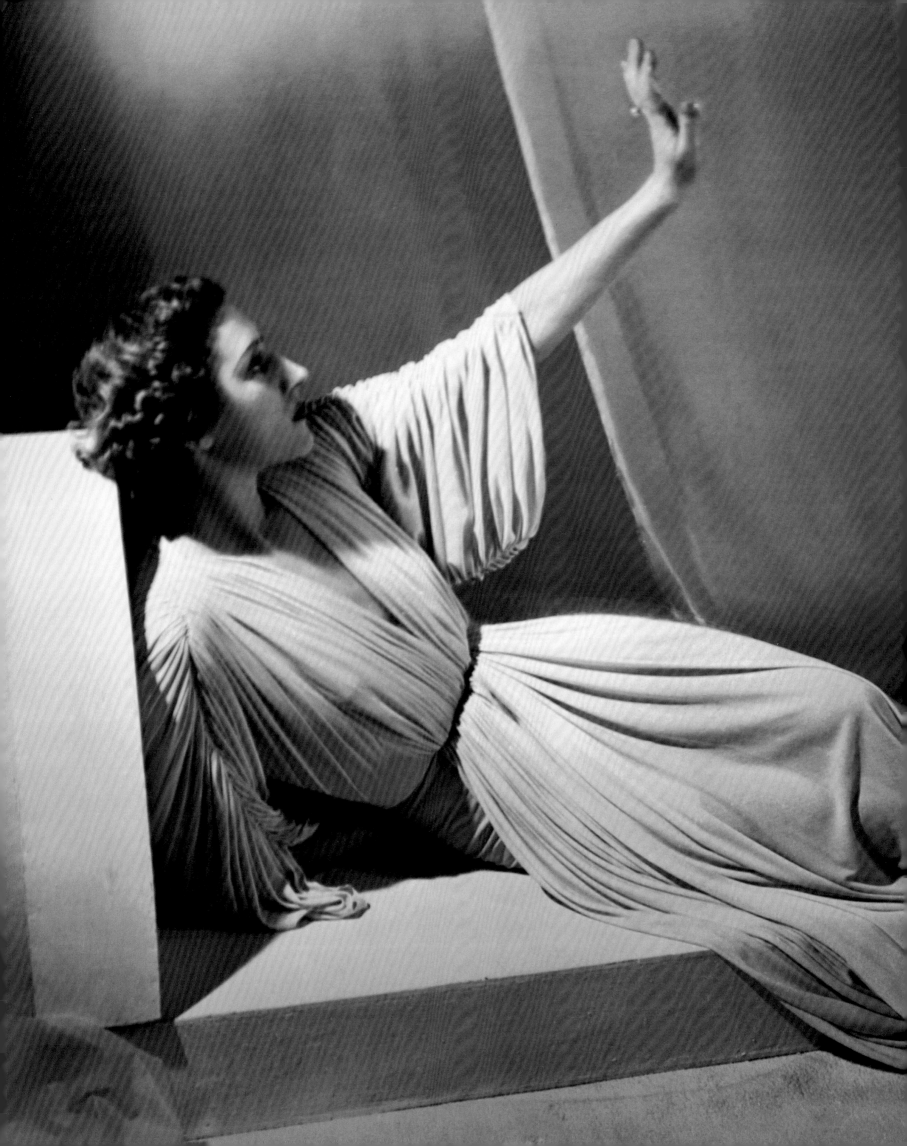

Evening dress
MADAME D'ORA, CIRCA 1936

99

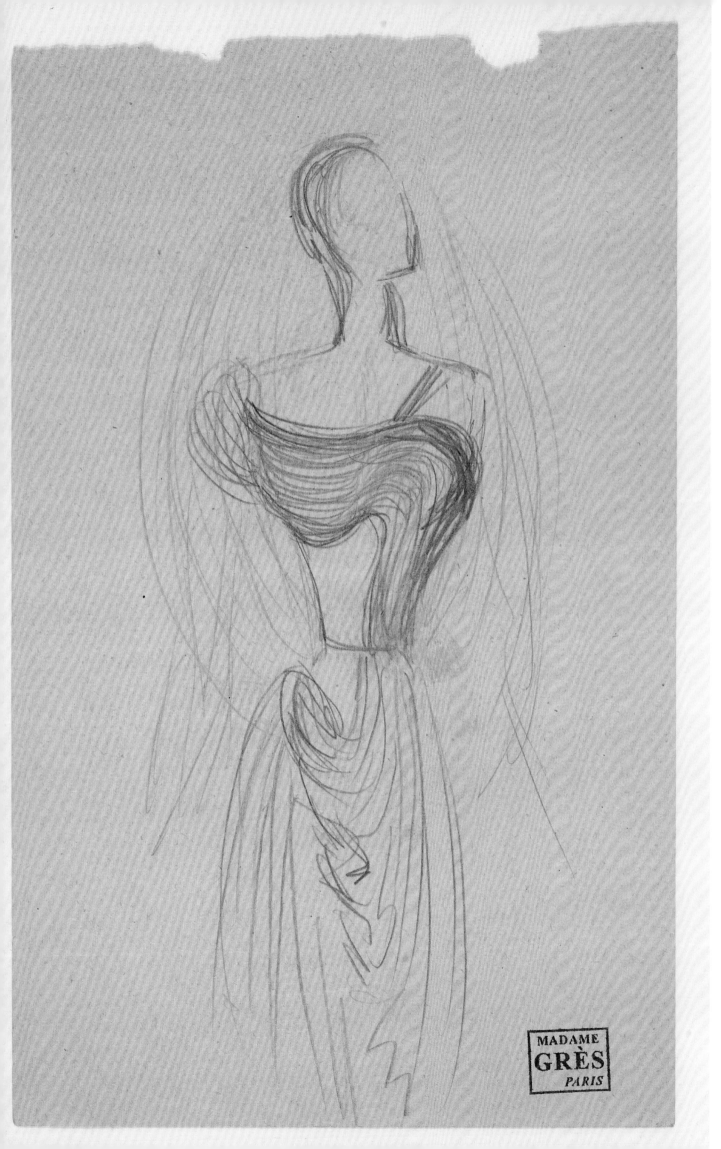

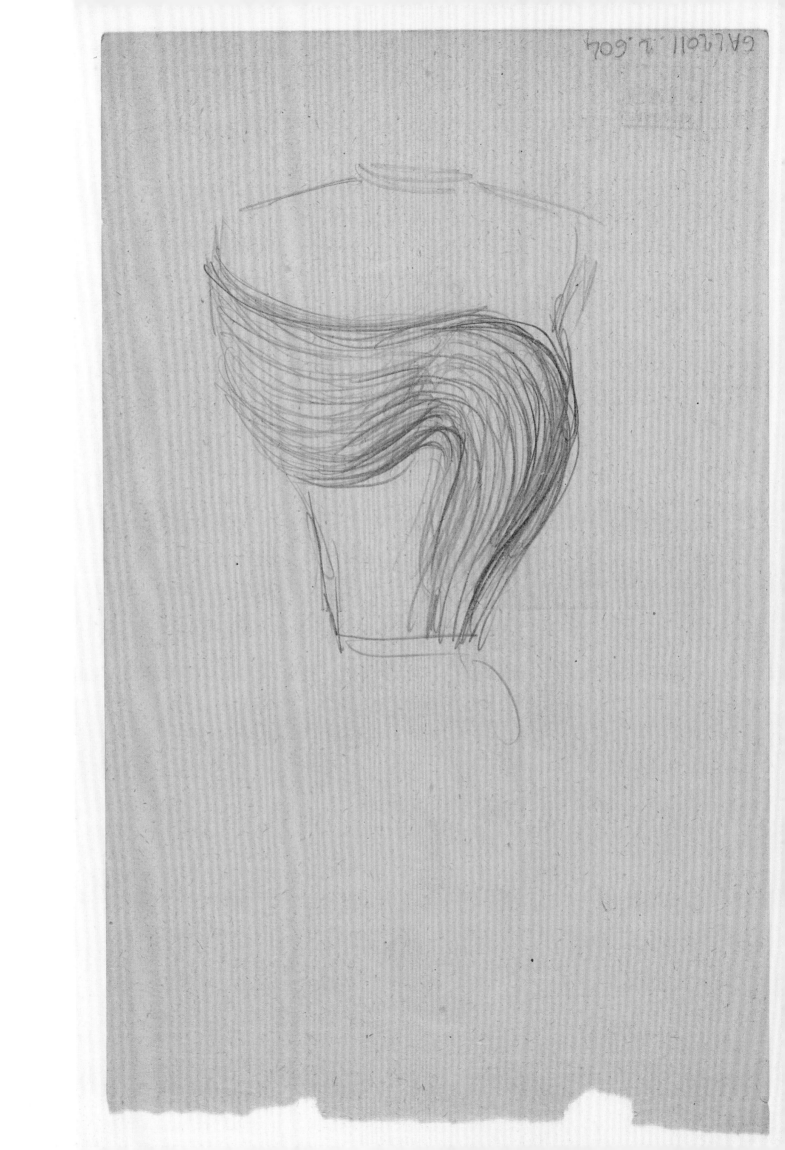

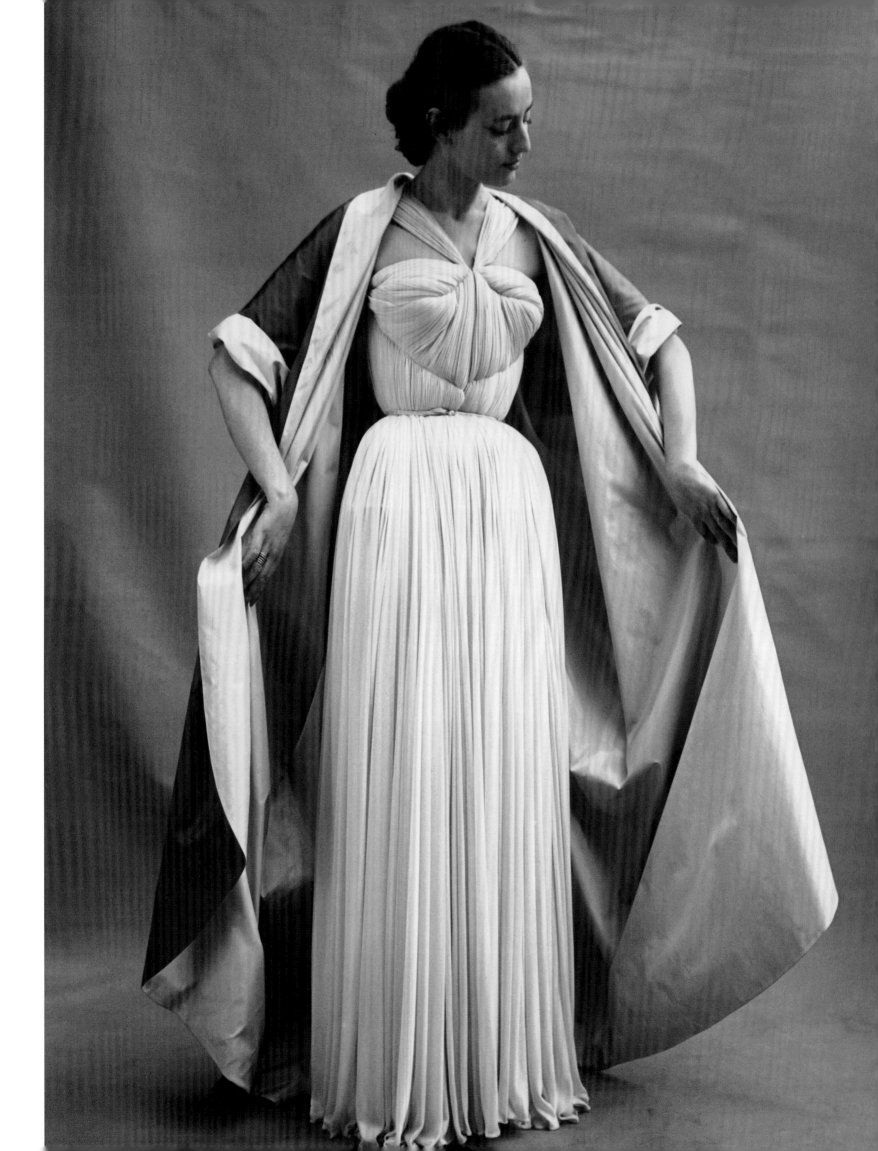

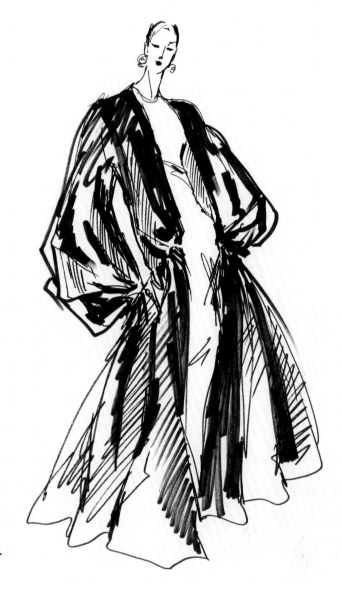

PÉ 87
44

PREVIOUS PAGES, LEFT AND RIGHT

Sketches by Madame Grès for
a pleated-and-draped dress (recto and verso)
CIRCA 1950

OPPOSITE

Evening ensemble composed of a dress in
ivory silk jersey and a coat in grey taffeta
ANONYMOUS, 1952

ABOVE

Collection drawing for a Grès
evening gown and coat
MARCEL ISOLA, SPRING-SUMMER 1987

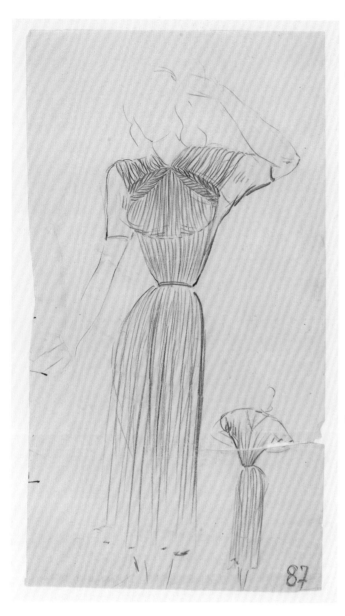

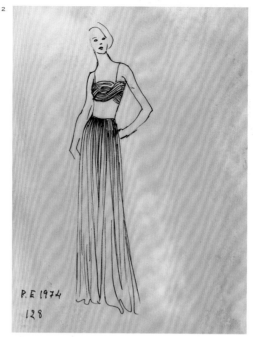

P.E 1974
128

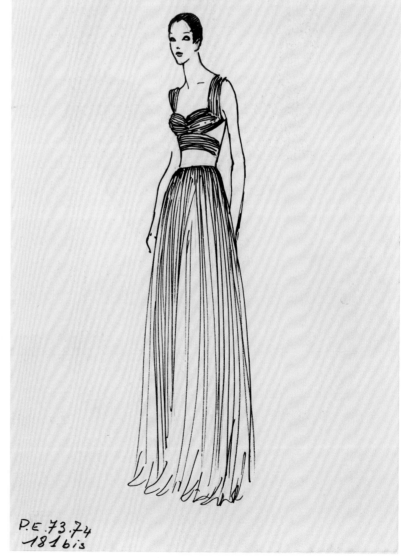

[1] *Design for a Grès pleated cocktail dress*
ANONYMOUS, SPRING-SUMMER 1947

[2] *Facsimile of a collection drawing for a Grès
evening ensemble from Spring-Summer 1939*
MARCEL ISOLA, SPRING-SUMMER 1974

[3] *Facsimile of a collection drawing
for a Grès evening gown*
MARCEL ISOLA, SPRING-SUMMER 1974

OPPPOSITE
Draped tunic
LUCIEN LORELLE, 1945

P.E 73.74
181 bis

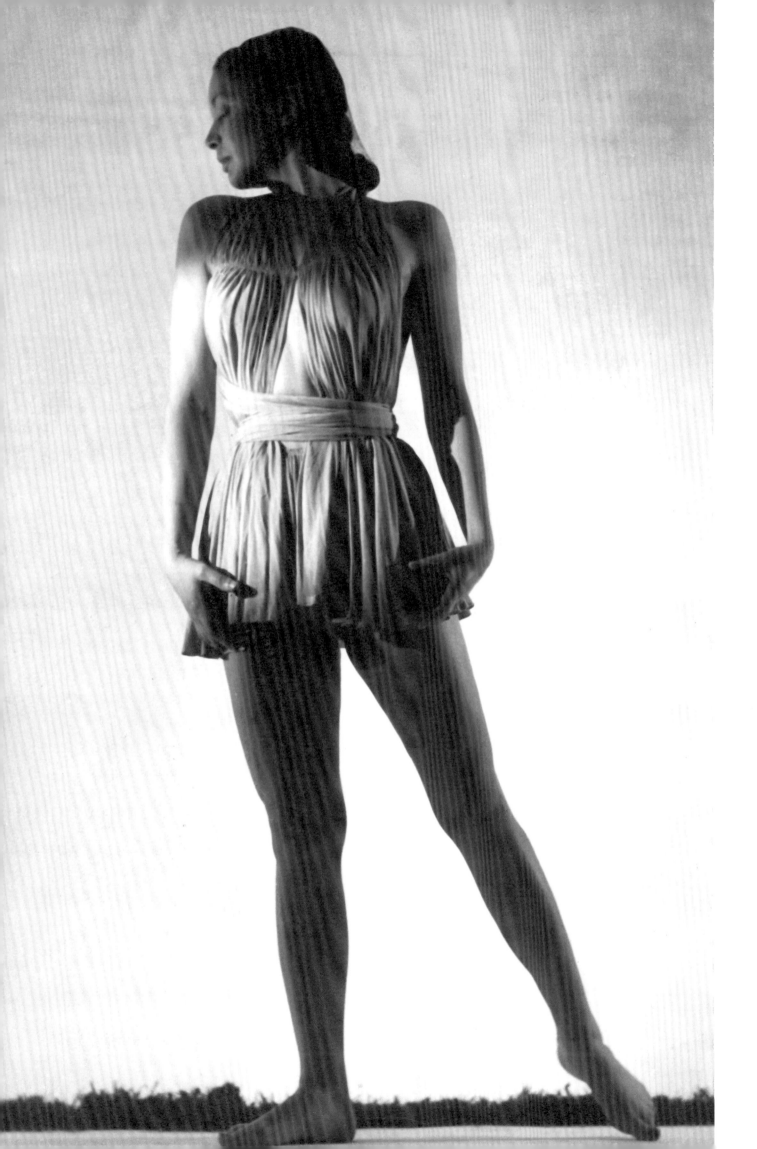

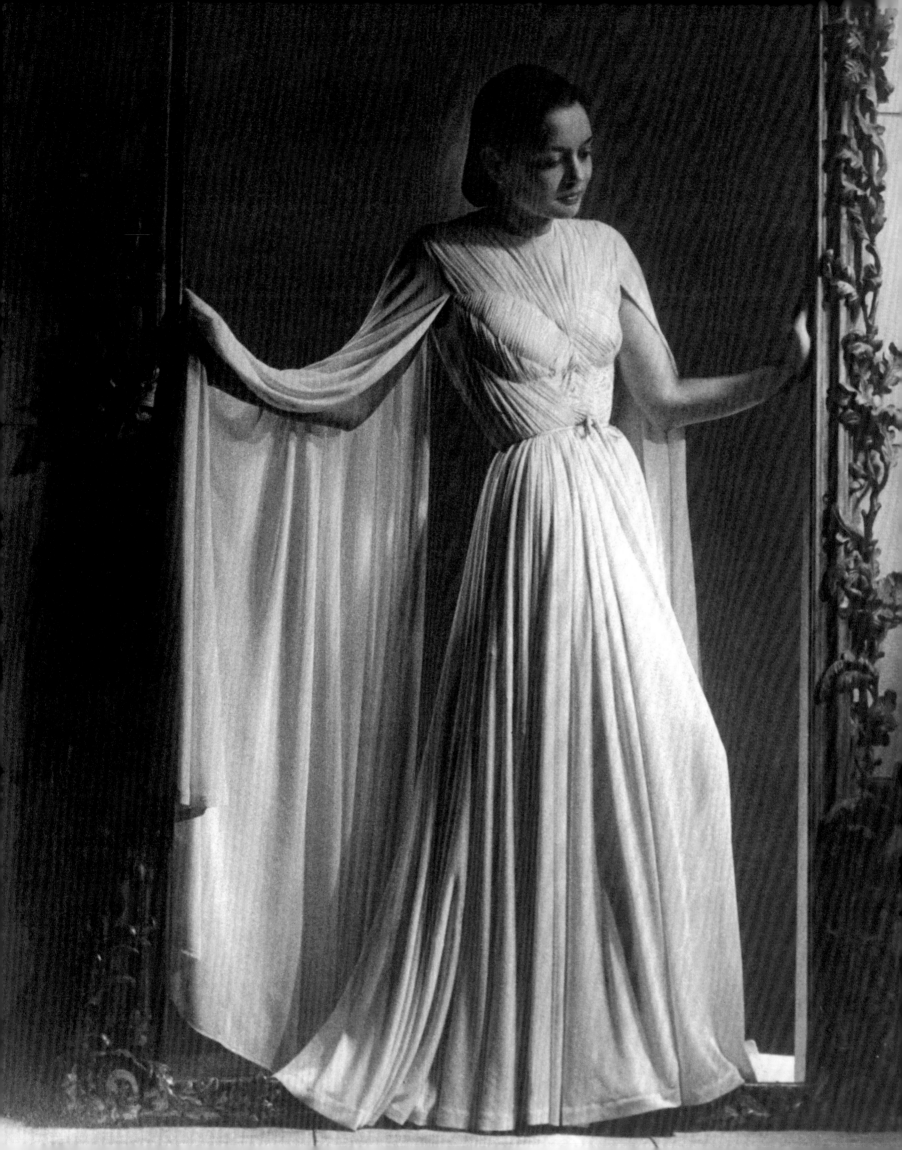

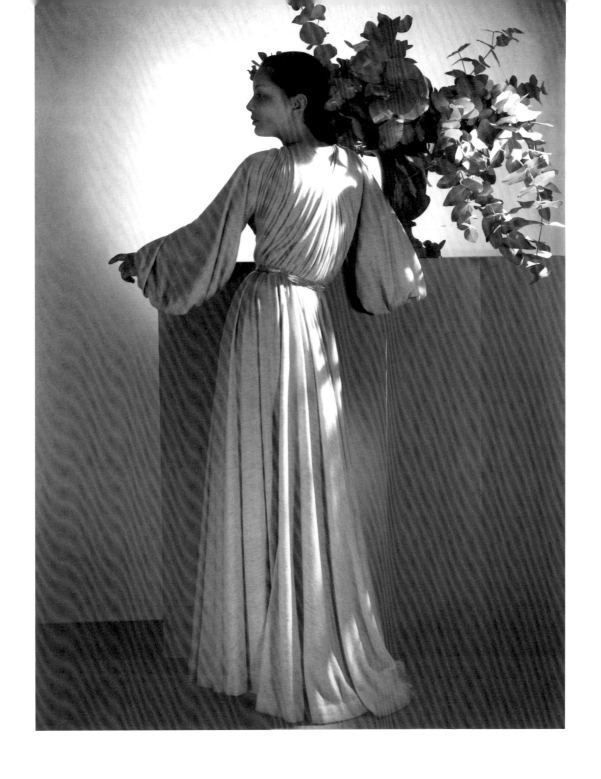

OPPOSITE
Evening dress
ANONYMOUS, CIRCA 1943

ABOVE
Evening dress in wool jersey
PHILIPPE POTTIER, 1942

107

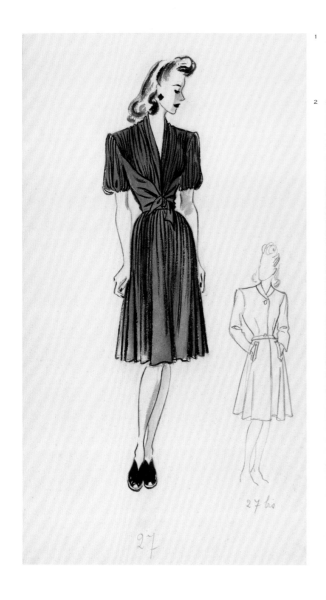

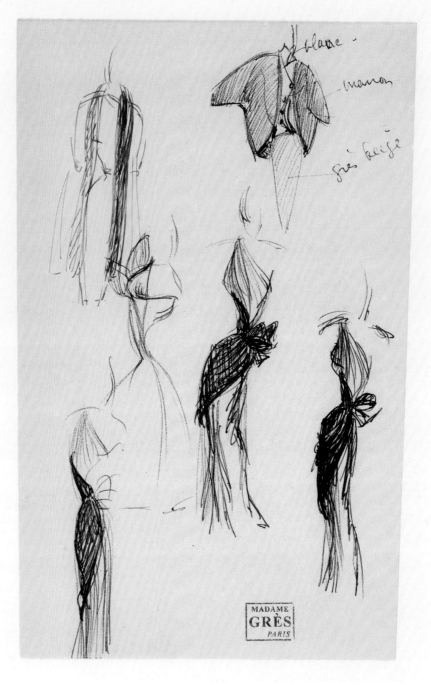

¹ *Collection drawing with gouache for a Grès formal ensemble*
ANONYMOUS, SPRING-SUMMER 1943

² *Sketches of ensembles and evening gowns by Madame Grès*
SPRING-SUMMER 1951

OPPOSITE

Preparatory sketch for a collection drawing for a Grès evening gown
ANONYMOUS, SPRING-SUMMER 1948

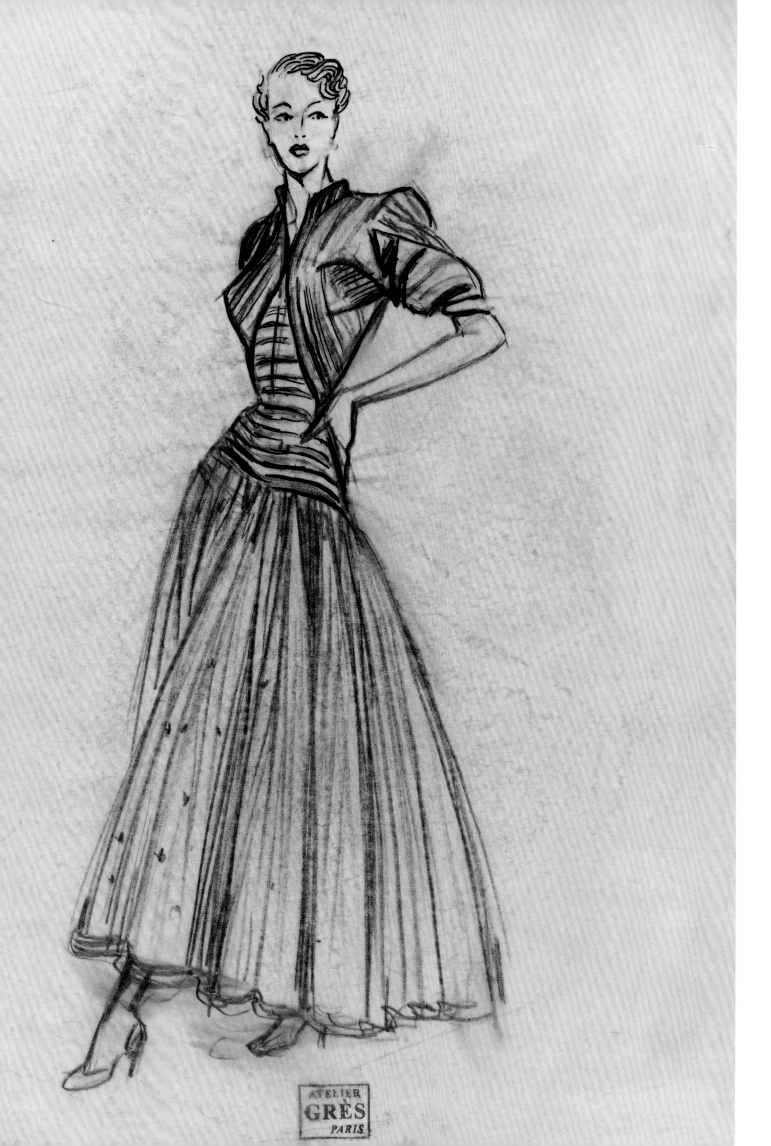

ATELIER
GRÈS
PARIS

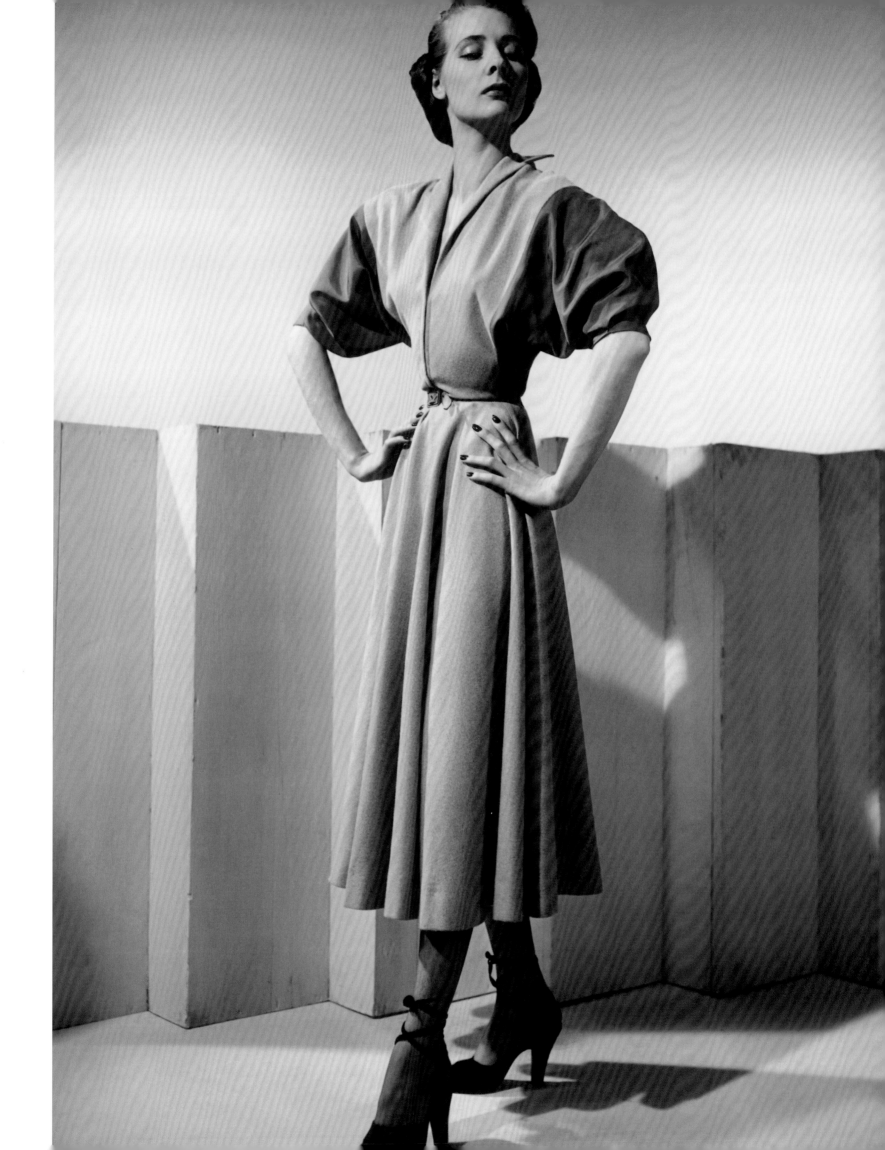

Day dress
JEAN-LOUIS MOUSSEMPES

*Design for a Grès pleated-and-draped
evening gown, from the sketchbook
"Présentation de robes à Zurich"
("Presentation of dresses in Zurich")*
ANONYMOUS, SUMMER 1945

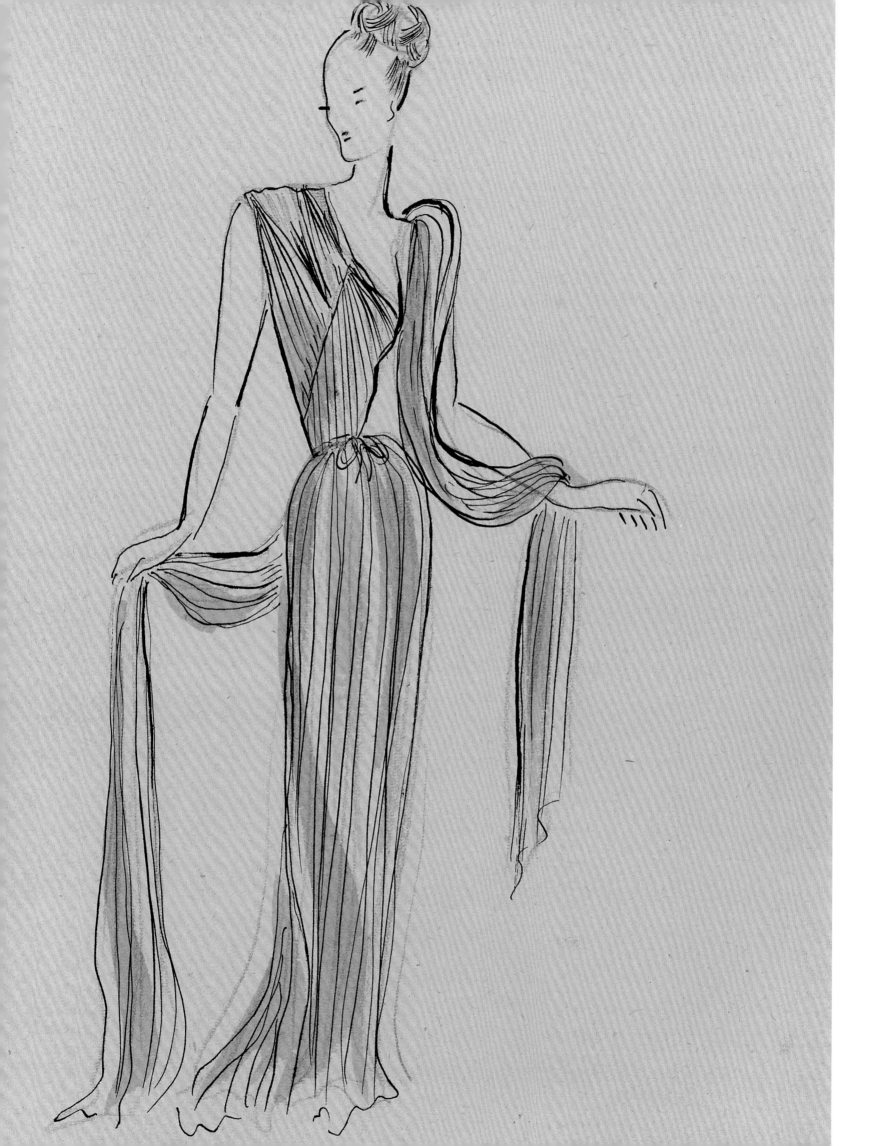

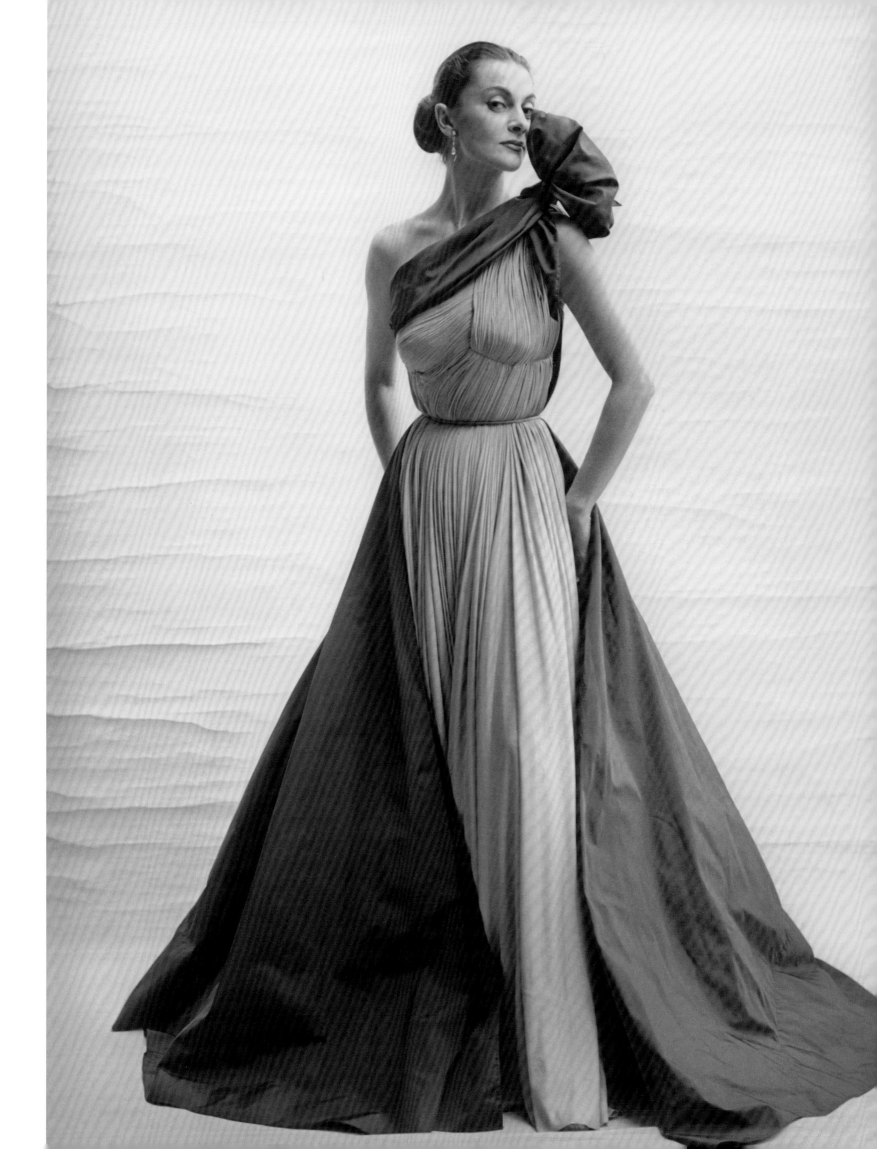

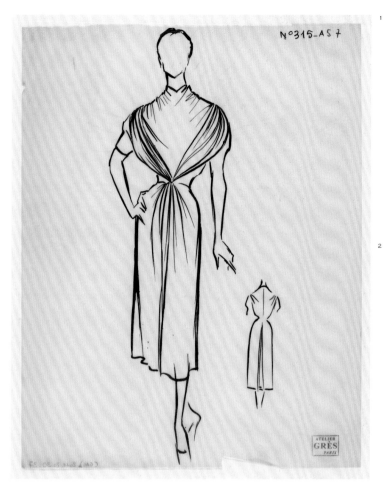

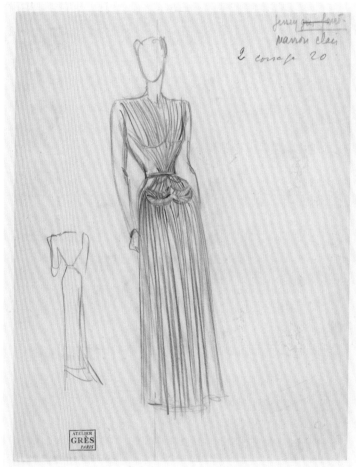

Evening dress in jersey and taffeta
MATTER & KUBLIN, 1951

[1] *Collection drawing for a Grès
afternoon dress*
MARCEL ISOLA, FALL-WINTER 1957

[2] *Collection drawings for a Grès pleated
evening gown*
ANONYMOUS, FALL-WINTER 1942

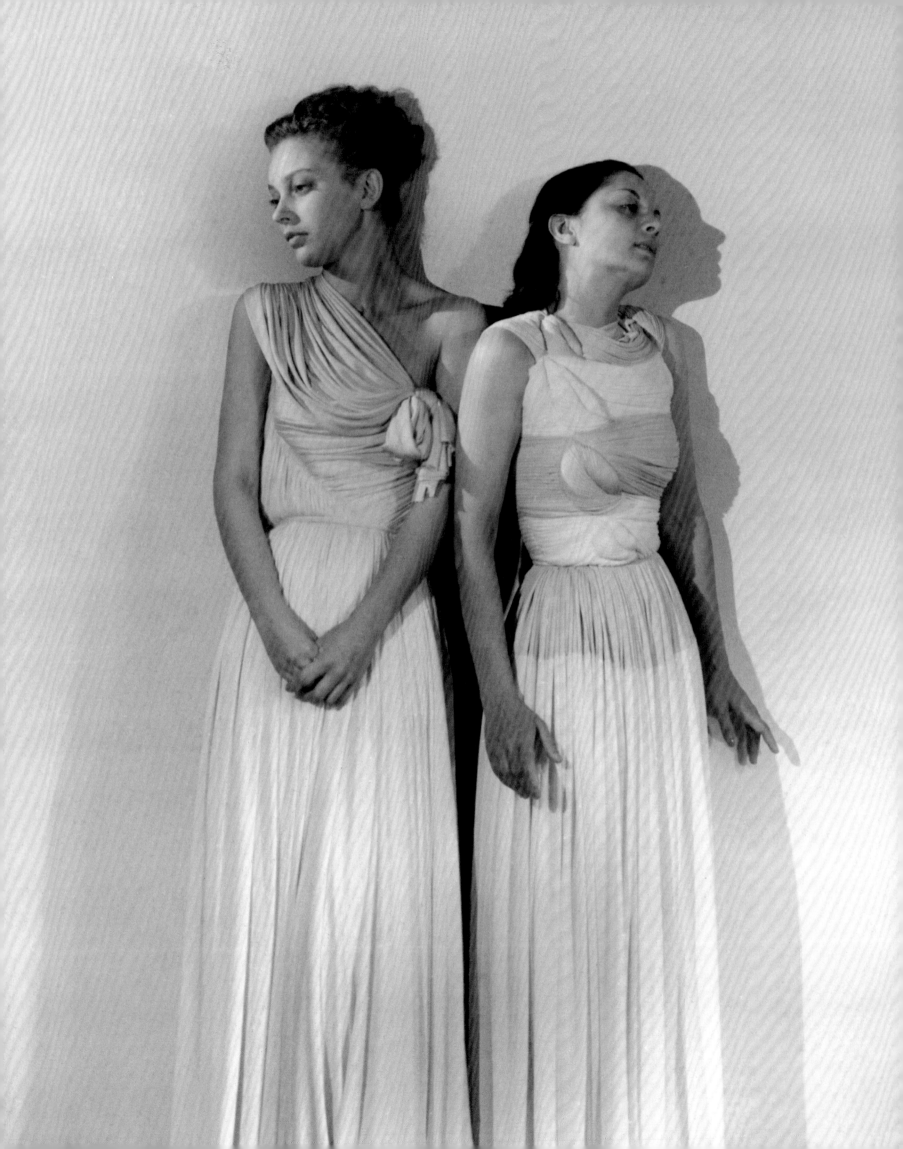

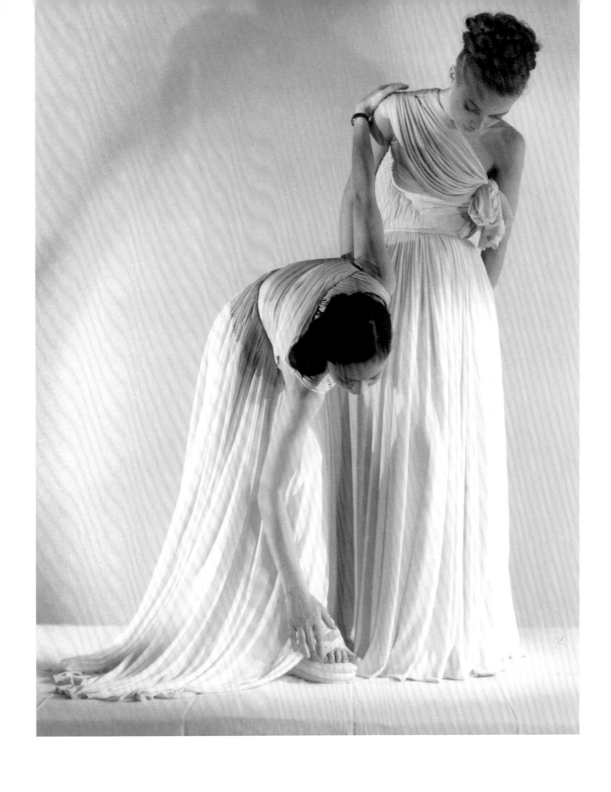

Evening Dresses
DANIEL MASCLET, 1945

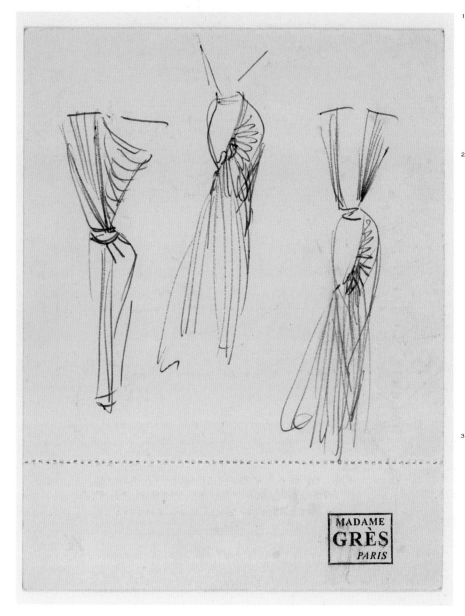

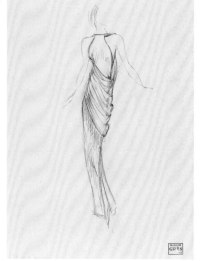

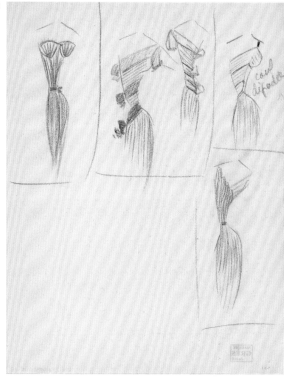

ABOVE

[1] *Sketches by Madame Grès for three pleated evening gowns on the back of an invitation to the "Deux siècles d'élégance (1715–1915)" ("Two Centuries of Elegance (1715–1915)") exhibition at the Galerie Charpentier on January 26, 1951*

SPRING-SUMMER 1951

[2] *Preparatory sketch for a collection drawing for a Grès sleeveless draped evening gown*

MARCEL ISOLA, SPRING-SUMMER 1986

[3] *Sketches by Madame Grès for five pleated dresses*

FALL-WINTER 1957

OPPOSITE

Evening dress in white silk jersey

ANONYMOUS, 1951

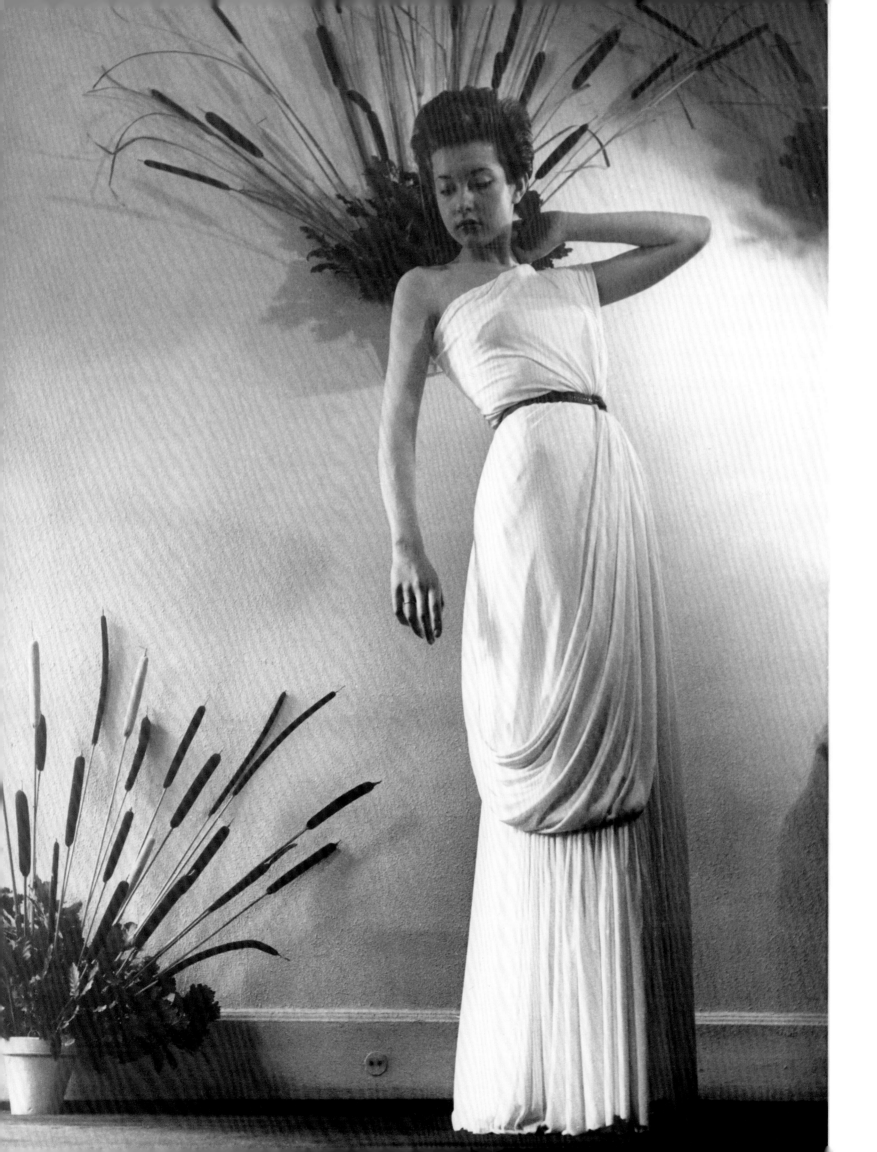

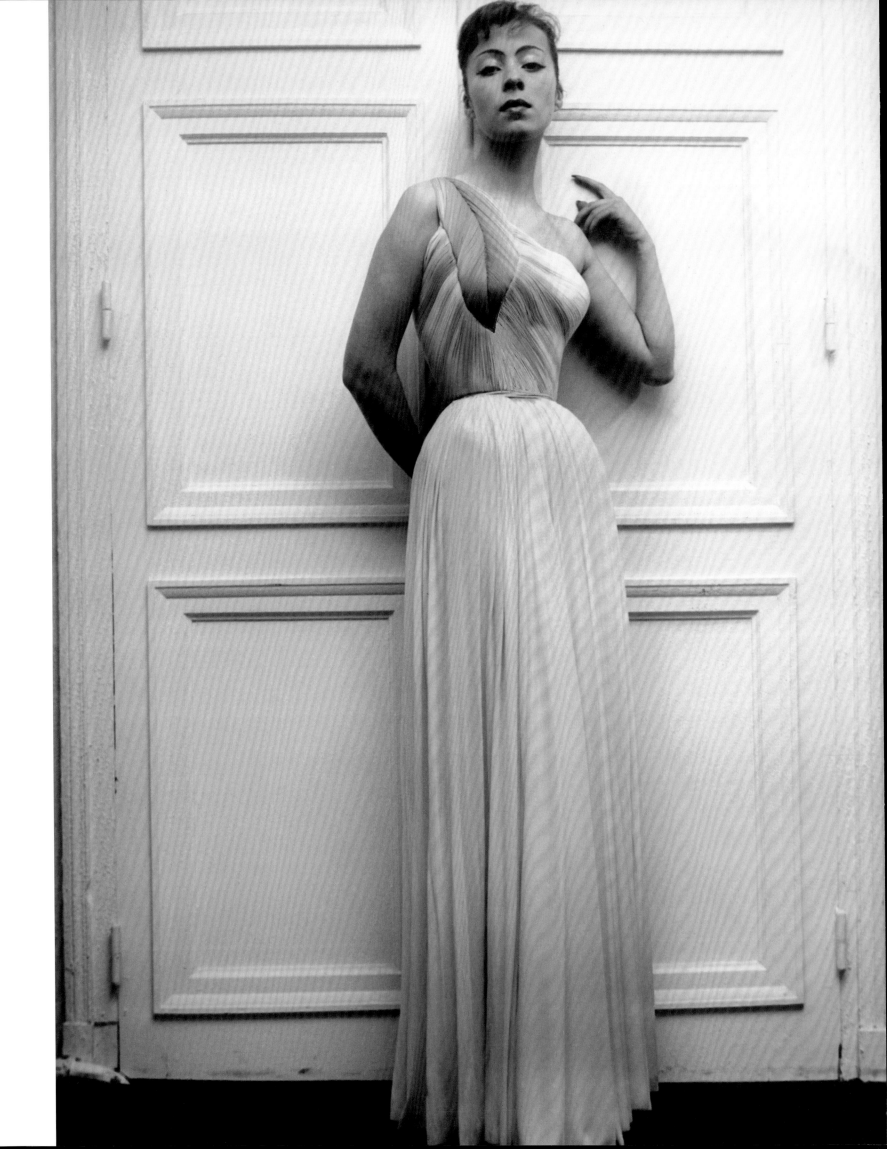

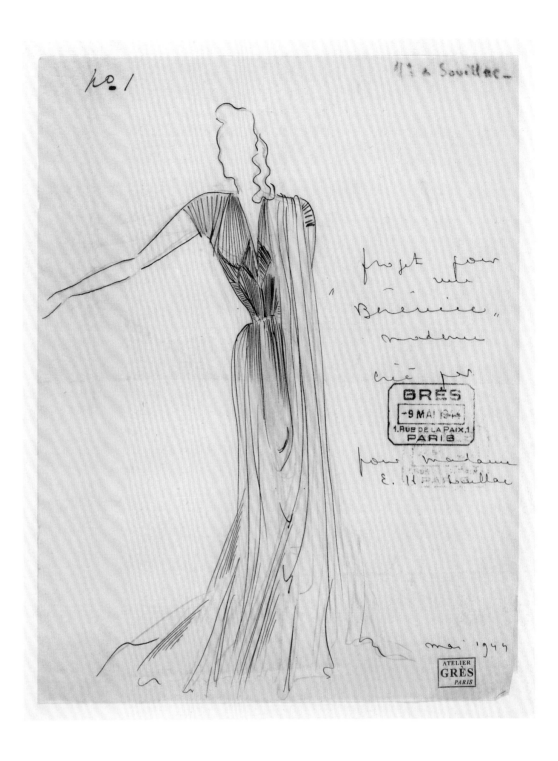

OPPOSITE
Evening dress
FRED BROMMET, 1954

ABOVE
"Design for a 'modern Bérénice',
created by [Grès] for Madame E.H. Souillac"
ANONYMOUS, MAY 9, 1944

121

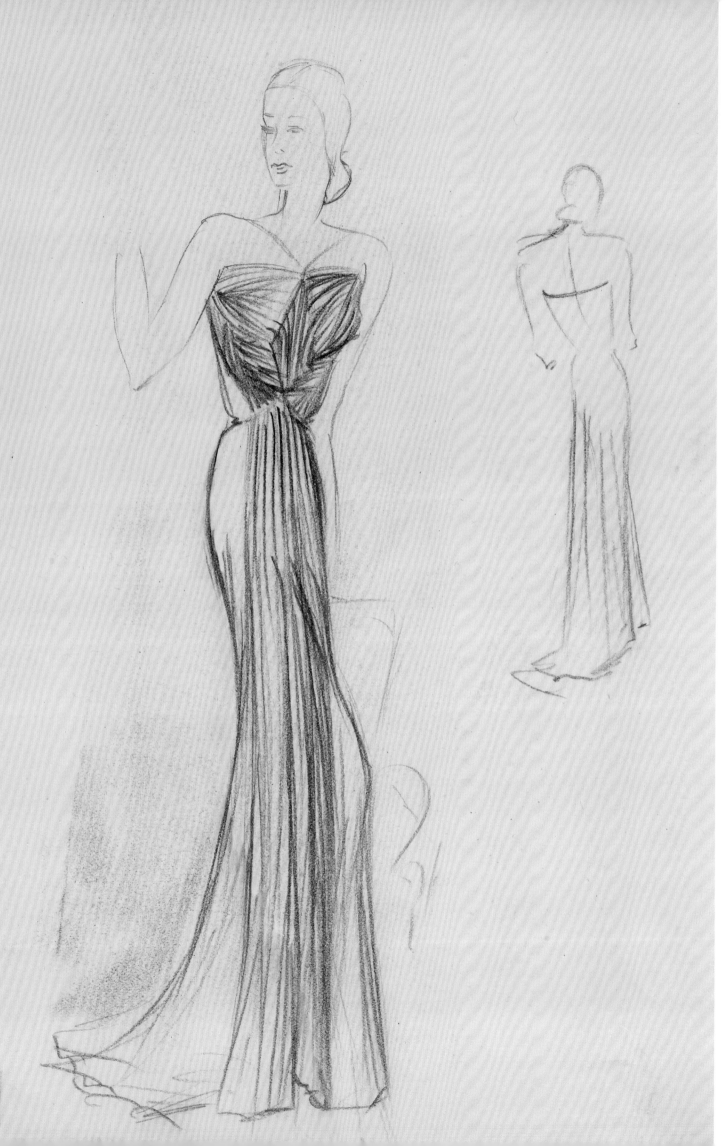

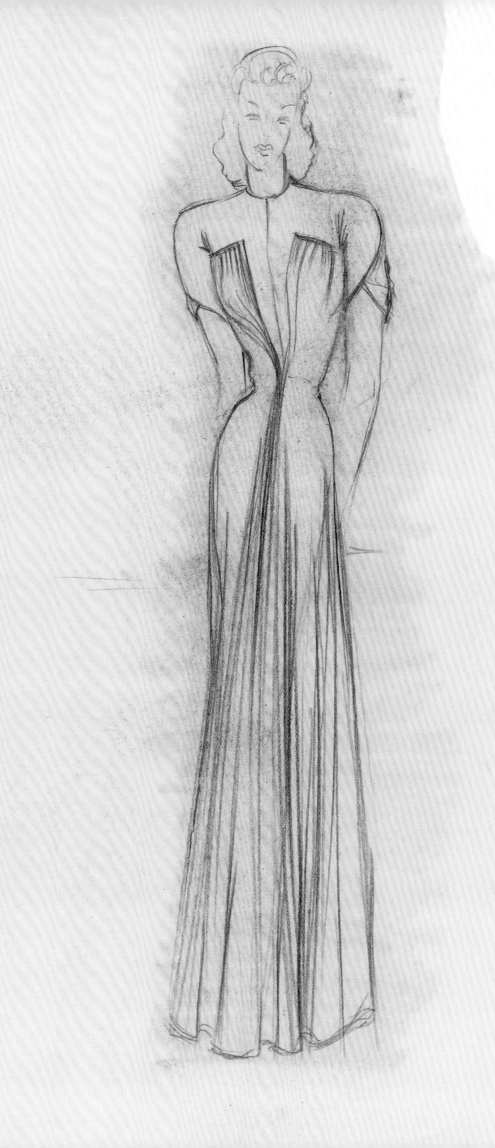

LEFT

Preparatory sketch for a collection drawing for an Alix long evening gown
ANONYMOUS, SPRING-SUMMER 1939

RIGHT

Preparatory sketch for a collection drawing for an Alix pleated evening gown
ANONYMOUS, SPRING-SUMMER 1939

OPPOSITE

Evening dress
DENYSE SMITH, 1948

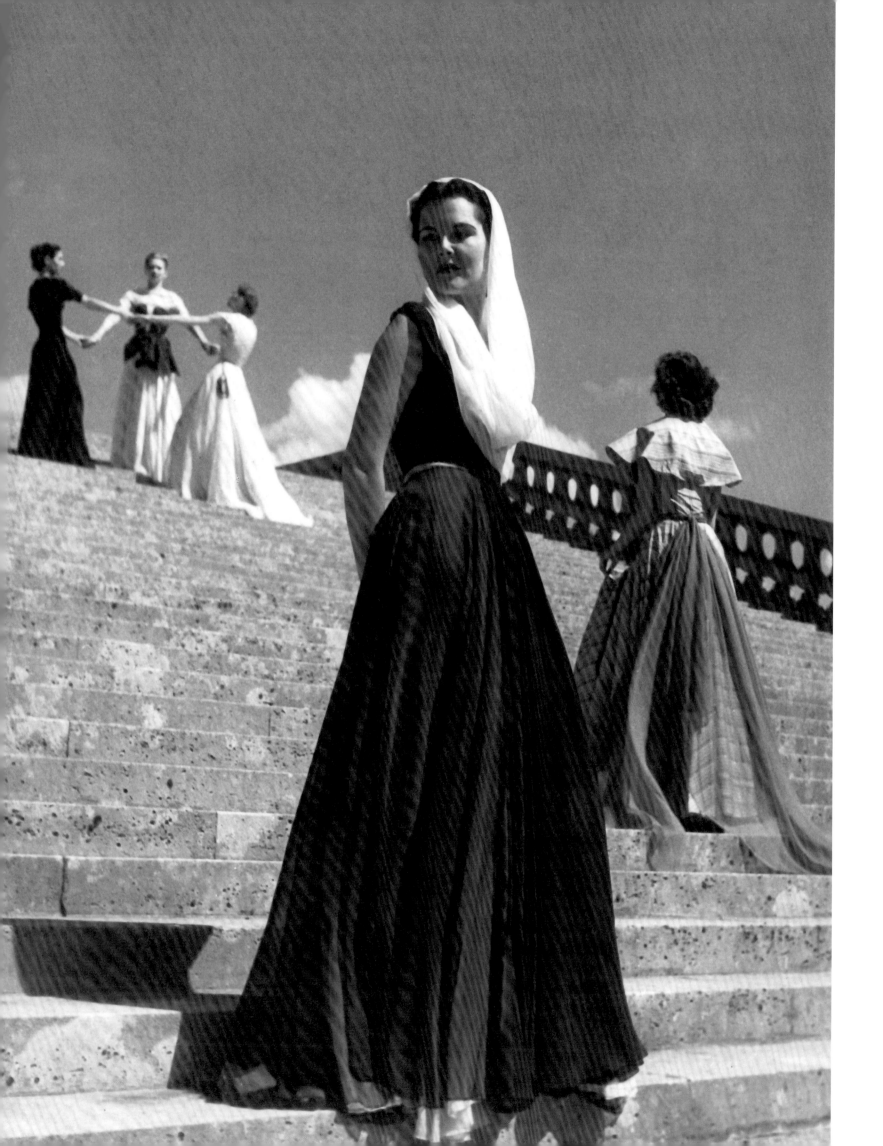

We would like to thank the institutions and persons that brought their suport and their precious help to this book:

Alex Delotch Davis, Rafael Gomes, and Emily Smith at the SCAD FASH Museum of Fashion + Film;

Miren Arzalluz, Alexandre Samson, and Sylvie Lécallier at the Palais Galliera, Musée de la Mode de Paris;

Isabelle Le Guern at Paris Musées;

Florence Hemici and Véronique Mamelli at the RMN–Grand Palais;

Carla Sozzani and Ariel Stark-Ferré at the Azzedine Alaïa Foundation;

as well as Gaël Mamine.

MADAME GRÈS COUTURE PARIS

FIRST PUBLISHED IN THE UNITED STATES OF AMERICA IN 2024 BY
RIZZOLI INTERNATIONAL PUBLICATIONS, INC.
300 PARK AVENUE SOUTH, NY 10010
WWW.RIZZOLIUSA.COM

© OLIVIER SAILLARD
TEXT "ELEGANCE AS A DESTINY" © ANNE GRAIRE

ART DIRECTION: FUNNY BONES

PUBLISHER: CHARLES MIERS
EDITORIAL DIRECTOR: CATHERINE BONIFASSI
PRODUCTION DIRECTOR: MARIA PIA GRAMAGLIA
MANAGING EDITOR: LYNN SCRABIS
COPY EDITOR AND PROOFREADER: LILLIAN DONDERO

EDITORIAL COORDINATION AND PRODUCTION MANAGEMENT: CASSI EDITION
VANESSA BLONDEL, CANDICE GUILLAUME
TRANSLATION: ABIGAIL GRATER

ISBN: 978-0-8478-3882-0
LIBRARY OF CONGRESS CONTROL NUMBER: 2024934417
2024 2025 2026 2027 / 10 9 8 7 6 5 4 3 2 1
PRINTED IN CHINA

MIX
Paper | Supporting
responsible forestry
FSC® C019910

VISIT US ONLINE:
FACEBOOK.COM/RIZZOLINEWYORK
X (TWITTER): @RIZZOLI _ BOOKS
INSTAGRAM.COM/RIZZOLIBOOKS
PINTEREST.COM/RIZZOLIBOOKS
YOUTUBE.COM/USER/RIZZOLINY
ISSUU.COM/RIZZOLI